Drawing
for
Pleasure

Also available in Pan Books

PAINTING IN WATERCOLOURS
PAINTING IN OILS

The principal contributors:

Norman Battershill lives in the Sussex countryside where he paints full-time, is a member of the Royal Society of British Artists, The Royal Institute of Oil Painters, the Pastel Society and president of the Society of Sussex Painters and the Arun Art Society. He is also tutor for the Pitman correspondence course in pastel. He regularly contributes articles to *The Artist* and is author of a number of books on painting and drawing.

Clifford Bayly trained at St. Martin's and Camberwell Schools of Art and until recently was Head of Department of Graphic Design at Maidstone College of Art. He is an associate member of the Royal Society of Painters in Watercolour. His work is exhibited regularly in the Royal Academy, the R.W.S. Bankside Gallery and other London and local galleries. His commissioned work can be found in Europe, America and Australasia. He lives in the Weald of Kent.

Richard Bolton was a technical illustrator, but has painted full-time for nearly five years. He exhibits in many London galleries and in Boston, Mass. Some of his paintings have been reproduced as prints. He lives in Cambridgeshire.

George Cayford ARCA studied at the London College of Printing and the Royal College of Art. Commencing as a graphic designer specialising in work for major London ballet companies, he also taught at Maidstone College of Art and is now a full-time lecturer at the London College of Printing. He has held exhibitions in London and Amsterdam, and his work is included in collections in England, Holland, Portugal and USA. He lives in Hampstead.

Margaret Merritt (also known as Margaret Pettersson) spent many years as official illustrator to more than a dozen botanical expeditions, mainly in the Middle East. She teaches botanical drawing and general painting at West Dean College of Rural Arts and Crafts, and at home and abroad. Her pictures are in collections in England, USA and Iran. She lives in a converted mill house near Guildford, Surrey.

Jack Yates studied at the Sheffield College of Arts and Crafts. For the past seventeen years he has been a lecturer at the Camden Arts Centre teaching figure drawing, portraiture, painting and experimental techniques. He has held sixteen one-man shows both in England and abroad, and has had his work shown in the Royal Academy. He is a regular contributor to *The Artist* and has published *Creating in Collage* (Studio Vista 1976) and *Collage* (Otto Maier, Germany, 1981).

The editor of DRAWING FOR PLEASURE, Peter D. Johnson, trained as a painter and studied Art History at the Courtauld Institute. He is consultant editor to the *Leisure Arts* series (published by Search Press); he has written several articles for *The Artist*; and also a novel *Making Waves*.

Drawing
for
Pleasure

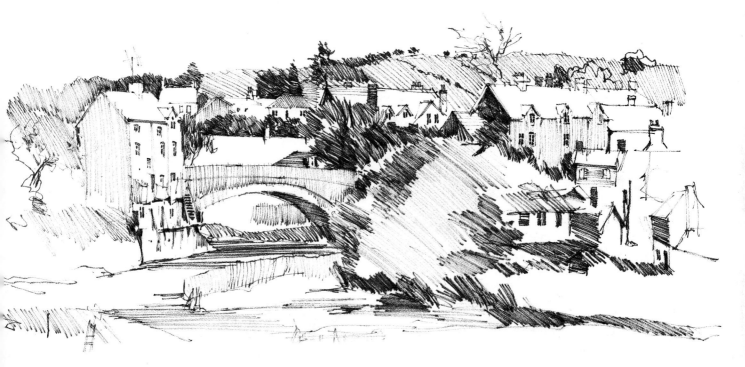

Norman Battershill Clifford Bayly Richard Bolton
George Cayford Margaret Merritt Jack Yates

EDITED BY PETER D. JOHNSON

PAN BOOKS
London and Sydney

First published 1983
by Pan Books Ltd
Cavaye Place, London SW10 9PG

and simultaneously by

Search Press Ltd
Wellwood, North Farm Road,
Tunbridge Wells, Kent TN2 3DR

Edited by Peter D. Johnson
Designed by David Stanley

Typeset by Studio .918, Tunbridge Wells, Kent
Printed and bound in Spain by
Edit. Eléxpuru, S.A.L. - BILBAO
ISBN 0 330 26971 2

Contents

Introduction

As in all languages, whether spoken or written, acted, sung, played or danced, making marks (or picture-making) is an essential form of enjoyment and communication. Often we do these things to please ourselves or a few others, but they are, nevertheless, an outward manifestation of one's own personality.

In this book I have garnered together as wide a selection from the contributing artists (whose book essentially this is) of works, diagrams, marks on paper as will, I hope, stimulate you to use the 'seeing eye', to select subjects that please you and explore them with the bountiful range of graphic materials now available on the market.

Most drawings are modest in concept but this does not mean the results are necessarily so — drawings on paper can be as directly appealing and as memorable as a simple but beautiful melody, popular or classical. Orchestrate them (to continue the musical analogy) with tone, wash or colour and they may be enhanced — but only to the point of being aesthetically sound. We nowadays sometimes forget that the simple, eloquent line has its own rhetoric, be it the most delicate of pencil outlines or the broadest of black ink bravura brush strokes. *Your* marks matter; they are your statement about what you perceive and feel, both outwardly and inwardly — for the world of fantasy, of course, also has its place in artistic expression.

Other than what the contributing artists hope to say with their drawings and their words to help you understand the processes of picture-making, there is only one real lesson to be learned from this book; whenever I have been listening to or discussing with them the preparation of this book they all reiterate one point — and it cannot be illustrated. 'Practise, practise, practise', is their unanimous message to all who wish to improve their skill at drawing. Making one's hand depict what eye and mind perceive was once as fundamental to us as mastery of the spoken word — yet, how often we dropped it in childhood or soon after. That is why I have started this introduction with the only photograph that appears in the book, and a child's drawing. The photograph captures the child's pleasure in her achievement, her drawing; and the intensity of the pleasure of making marks which mean something — to herself or others, it matters not. If you enjoy making marks, lines, shading — doodling even — why not extend your own pleasure?

This book is about drawing for pleasure. The contributing artists — Norman Battershill, Clifford Bayly, Richard Bolton, George Cayford, Margaret Merritt, Jack Yates — are not only professionals but teachers of the subject. They are willing to share their skills, techniques and enthusiasm to help you to make the pictures that will give you the self-satisfaction that is bound up with all creative endeavour.

After the opening sections on fundamentals, this book is divided into broad subject areas. However, although I asked each artist to contribute mainly to one section or another, no single one has an outright monopoly, for I have added to them the works of the others, to give contrast and breadth. Occasionally I have delved also amongst the Search Press collection for works by other artists — John Blockley, Dennis Frost, Peter Gilman, Leslie Worth — and have included them to provide as wide a range of picture-making as I could find.

In the crucibles of their studios I spent many hours — days even — with the contributing artists, making notes and tape recordings of what they said while we discussed the preparation of this book. As editor I have used, whenever possible, their words, not mine — for it is their drawings they are talking about, their hints, their secrets that are passed on to you in this book.

Drawing for Pleasure then, is by the nature of its contents an *encouragement* — not a textbook — to be enjoyed and used as such. Read it from start to finish; or dip into it at random (it is designed for that also!) to refresh your memory on the many techniques and media that are yours for the grasping. Drawing is fun as well as communication. It can be made all the more pleasurable by mastering at least some of the ideas so freely given by the artists whose work and words are here so generously represented.

PETER D. JOHNSON

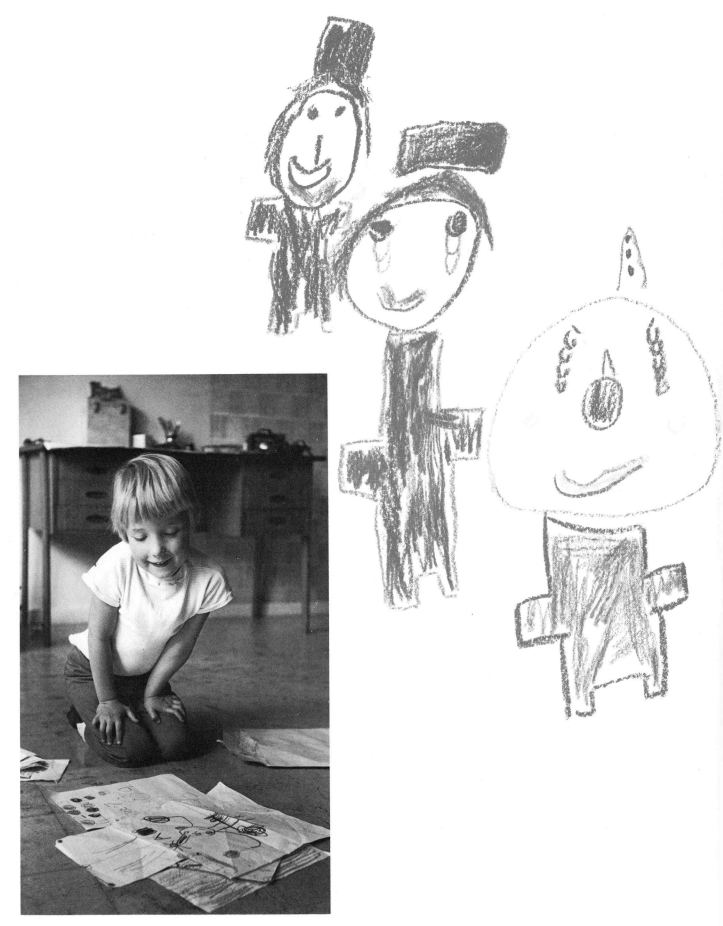

Introduction

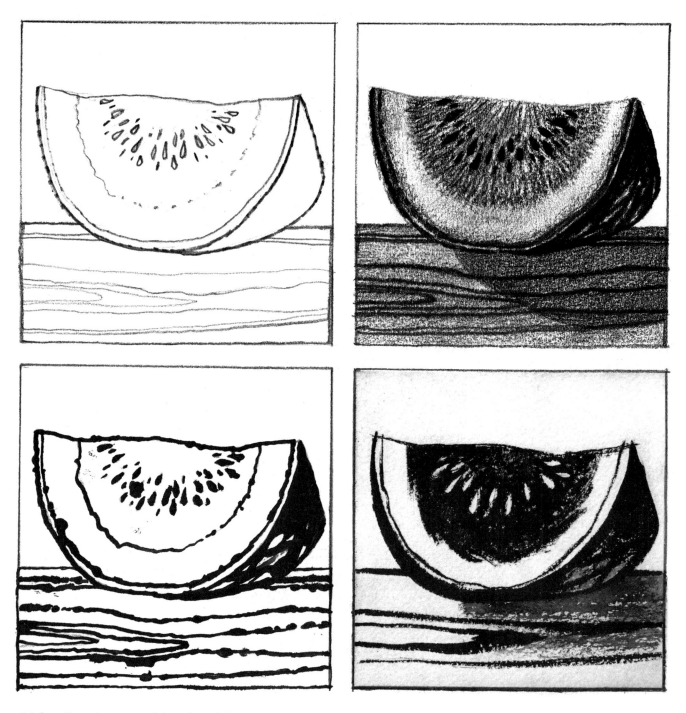

Melon slice: the same subject, four different interpretations. Top left: *pencil.* Top right: *crayon.* Bottom left: *pen and ink.* Bottom right: *brush and black ink on rough-surfaced watercolour paper.*

Materials

Materials

You can draw with anything which makes a mark, from a simple stick of charred wood to the sophistication of computer graphics! However, the marks you make with them will be meaningless if they do not produce a useful description of what you have seen and perceived, be it simple or complex. Your choice of medium should be dictated by the type of drawing you intend to produce and the purpose for which it is being made. For this reason, and precisely because of the enormous range of materials on the market it is all the more essential to appreciate their inherent qualities and respective characteristics.

Charcoal consists of twigs or thin sticks baked at a sufficiently high temperature until evenly charred throughout their thickness, giving an even black quality to the lines when used. A medium to coarse surface paper will give best results. It smudges easily and can spread to parts of the drawing intended to remain light — yet this is its essential characteristic and should be utilised whenever possible.

Chalk can be taken to include pastels, soft or hard; but unlike natural chalk which contains a certain amount of clay and other matter, pastels are made by compressing powdered pigment with some chalk and therefore the softness or hardness can be controlled.

Light chalk/pastel can be used very effectively to highlight charcoal drawings. Conté crayons (a special form of hard pastel) are less likely to smudge than pastel but they come in a limited range of colours: usually black, brown and white.

Pencils range widely from very soft (7B) to very hard (6H). Special pencils are also made, such as carbon and conté pencils, in several grades. These are useful for good blacks but are subject to some degree of smudging. Clutch pencils — those which grip a separate lead element — can be useful where it is impracticable to keep sharpening a standard wood pencil.

Below: *the various marks made by many of the mediums mentioned in the text. The two bands on the left were made on smooth paper; the two on the right on rough-surfaced watercolour paper.*

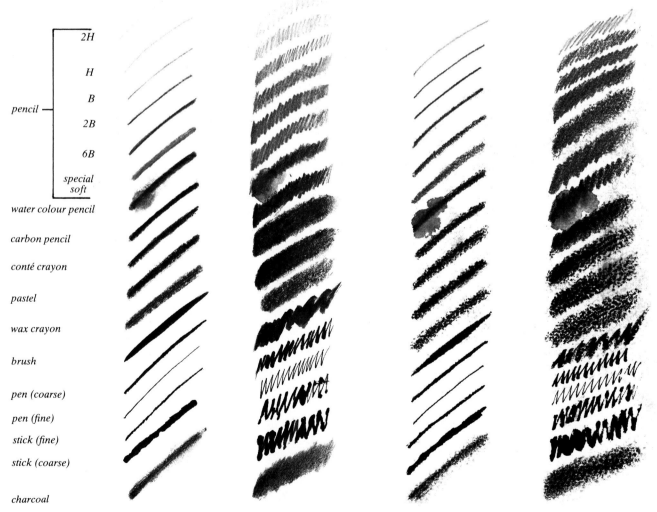

pencil — 2H, H, B, 2B, 6B, special soft

water colour pencil

carbon pencil

conté crayon

pastel

wax crayon

brush

pen (coarse)

pen (fine)

stick (fine)

stick (coarse)

charcoal

Crayon covers a variety of composite materials either in sticks with paper wrappers such as wax crayons or in special compositions of pigment and binding elements contained within a pencil format. Watercolour pencils fall into this category.

Pens. The most basic form can be a sharpened stick dipped in ink. It gives a reasonably good line and can produce an informal quality — blobby, but useful in landscape and strong textural drawings. Quills, steel nibs, fountain pens and special drawing pens are all developed from this basic principle.

One type of pen which uses a completely different system is the ball point. This is most useful when one needs to make notes unexpectedly and it can give good results when clear specific, descriptive drawing is required. It gives a rather characterless line, however.

Felt tip pens and markers come in an enormous range, both in black and in many colours, water soluble or water resistant. Throughout this book, especially in the sections on colour, you will see how our contributing artists have used these versatile media. Clifford Bayly warns, however: 'they have their uses but avoid using them indiscriminately until you develop sufficient confidence to experiment and decide for yourself their advantages and disadvantages'. Using coloured felt tip

Above: left, middle and right: ballpoint, felt tip loosened with water, soft pencil. Below: black conté crayon.

pens and marks is dealt with more fully in the sections on 'Using Colour'.

Brushes. Drawing with a brush takes us near to painting but nevertheless it is possible to draw with one. Drawings can be supplemented most effectively with the brush by adding washes and texture or by using the brush to produce heavier lines or to soften the drawing by dissolving away parts of the existing work.

Inks. For pen or brush work it is advisable to use soluble inks or watercolour. Black fountain pen ink is very useful manuscript ink — black and sepia inks are especially formulated not to clog the lettering nibs or quill and are very good for drawing. Chinese stick ink gives beautiful greys and soft black; dissolve the solid ink stick by rubbing it into a saucer or other shallow palette. Waterproof inks, once they are completely dry, can take watercolour washes over them. When you wish to thin inks, use distilled water or rain water. Tap water can cause many inks to curdle.

Other materials. A fixing agent may be necessary when using charcoal, carbon, conté crayon or pastel. The

11

Materials

most convenient system for applying this is by aerosol spray. If you have to use an eraser, modern plastic erasers are probably best as they stay cleaner. Putty rubber is useful for erasing charcoal but do not rely on erasers: practise your drawing without them whenever possible, unless you deliberately lay a tone and wish to pick out highlights in it.

Papers and surfaces. Bleached rag provides the best modern quality papers; Esparto (grass) and wood pulp are used for the less expensive to the cheapest. Papers can be hard, soft, rough, smooth, white or coloured, from the thickness of stiff board to the flimsiest of tissues. But do not be put off by the range available — most artists record what they have to say on whatever is handy, unless they contemplate beforehand a considered drawing. George Cayford likes to draw in colour on sugar paper — the stuff that is supplied to primary schools. As he says: 'It gives me the coloured background I like, its surface is sympathetic — and it is very cheap'. Try drawing on sketching paper or on a layout pad — even a lined exercise book is better than no paper at all. Most important, always have some available (together with a drawing instrument) at home, or in your pocket or bag when you are out of the house.

Using your materials. Unless you are making quick, on-the-spot drawings, when the main object is to record as quickly as possible the subjects that catch your attention, it is best to be as comfortable as possible. A flat table is the most convenient surface on which to place your paper, but a tilted drawing board will allow your drawing tool to move over your drawing surface without having to stretch your arm at the top or cramp it to your body in the lower portions. Arrange yourself so that any shadows caused by your drawing hand fall away from the point of contact of your drawing tool and you can see the strength of line or tone clearly. Flex your drawing arm all over the paper before you begin — if it casts distracting shadows move your position (or the lighting) until you are able to see the whole of your drawing in an even light while you are working on it.

Two of the commonest ways of holding your drawing instruments are shown in the pictures below (*left*). The one that comes easily to most people is how they grip a pen when signing their names. The other depends less on finger or wrist movement than on moving your whole arm — you will find most professional artists employ it — as it allows you to make marks in any direction with more ease and eventual control. Keep your wrist and forearm free of the drawing surface whenever possible: try and realise your work 'from the shoulder'.

The flower drawing below was done with charcoal pencil on tinted Ingres paper, then fixed.

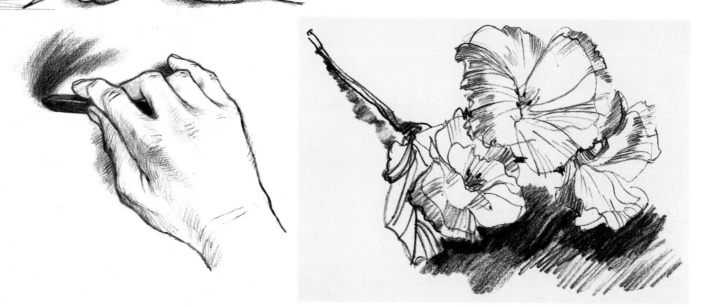

12

Marks

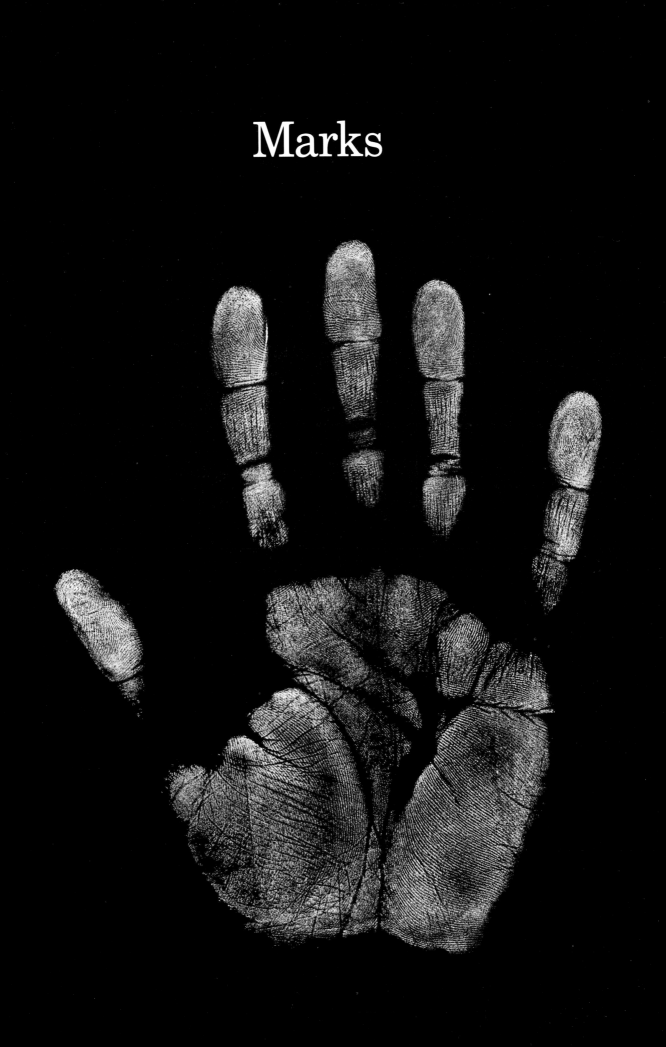

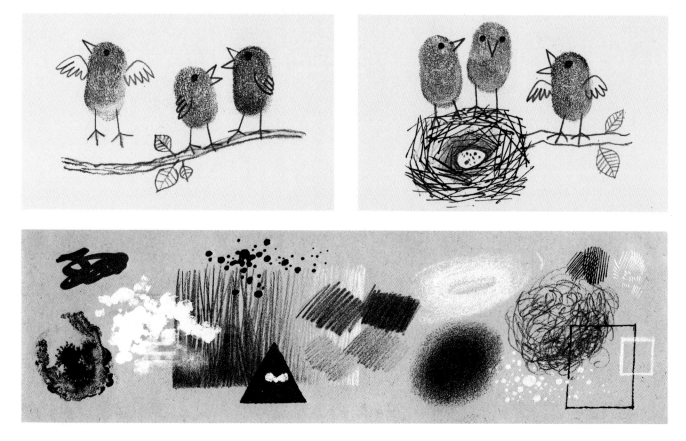

Marks

Drawing has come a long way since man's earliest attempts at visual communication. Making marks in wet clay or sand; scratching marks on stone; indicating, perhaps with a burnt stick, on a flat surface were some of the ways primitive man amplified his communication system with his fellows. As Clifford Bayly says: 'Drawing is still a most important and basic means of communication when describing objects, systems, processes and expressing personal ideas. Nowadays, making marks on flat surfaces, whether in black and white, or in colour, has reached a high level of sophistication, whether through such processes we wish to *inform* others about our ideas, or to convey our *feelings* about what we have seen: these two can be designated *objective* and *expressive* but in many cases each interacts and overlaps to a greater or lesser extent. The term drawing embraces now a very wide number of practical activities, which reflect the artist's ability to *observe* the subject objectively and *perceive* it subjectively. The result can be meaningless unless it is the result of intensive and careful observation by its creator, whatever the emotional response the subject projects to the onlooker.'

Drawing must be contained within the poles of objectiveness and expressiveness, according to whom you wish to communicate your ideas. Understand the process of communication by marks, and you will have grasped the fundamentals of what drawing is about. As

this book is about the pleasurable and aesthetic aspects of drawing, Clifford Bayly begins this section (*page 13*) with a print of his own hand (probably the most primitive identifier, and still used by forensic experts) and shows, (*above*), how he has transformed his finger prints into avian conversation pieces!

We have already discussed materials. Let us now look more closely at the marks they make and into the possibilities these offer us to record visual experiences and express our reactions to the subject. We need to develop a broad knowledge of how to produce these marks and be aware of their individual qualities so that we can use them skilfully — in short, to be technically as well as visually in control of our work.

A line is a mark — so too are finger prints, a smear, spots and droplets, blots, scratches etc. — all these can play a valuable part in drawing. In fact any mark is useful but only when it is appropriate to what is being expressed in the drawing. Bayly says, 'illustrated here are many such marks. In isolation they are meaningless, so I have shown some examples which occur naturally in drawings.

'Do not become preoccupied,' he goes on, 'with the quality of marks for their own sake. It is possible to produce decorative effects that are attractive (as in some forms of illustration) but of little use if they do not carry useful information or express the subject satisfactorily. The way marks are applied to the paper tends to reflect the attitude of the artist. Broad strong direct strokes reflect confidence and an interest in the basic qualities and mood of the subject; fine precise line

14

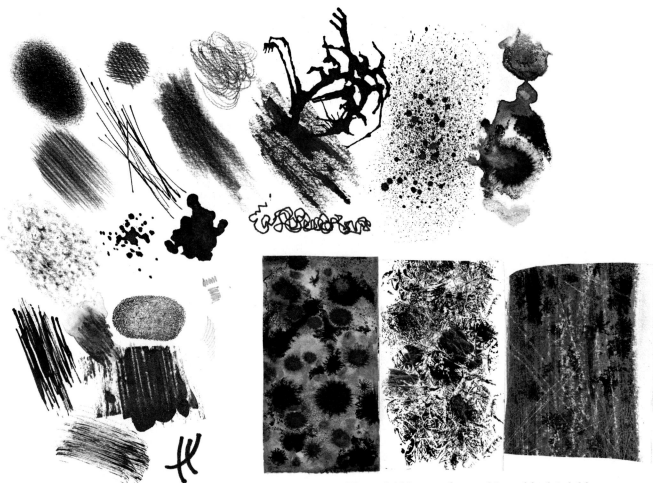

Blots, dabbings and scratchings: black ink blots on dampened paper, rag dabbings in black ink, Chinese ink wash and wax crayon; when dry, scrape with knife point.

Panel, middle page 14, on grey smooth board. *Felt marker, ink blob and water, Chinese white, soft pencil shading off to white crayon, black ink, charcoal, wax crayon, white crayon, black wax, carbon pencil, waterproof black and white inks with pen.* Above, on white cartridge paper. *Pencil, black ink with pen, ink blobs blown about with a straw, ink spatters, black conté, charcoal pencil, wax crayon (and scraped with a knife point), rag dipped in ink and dabbed onto the paper, fingerprint in black ink. See if you can imitate some or all of these marks for yourself by blobbing, flicking, shading, scratching, scribbling, washing over with brush and water, on several different kinds of paper. Your efforts may surprise and please you!*

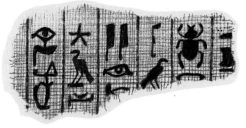

Ancient communication: Egyptian pictographs or hieroglyphics cut into and painted on the stone of a tomb.

work might show an intensity of interest in structure and detail.

'Just as the artist's *subjective* attitude to his subject is reflected in the quality of the marks made so we have to make a conscious *objective* effort to use appropriate marks related to the subject matter we are portraying. If we rely entirely on marks we are likely to neglect the concepts of form and structure. These must be present simultaneously in our drawings, otherwise they will appear flat and formless. Decorative and illustrative work can exist in a two-dimensional form but if you are hoping to represent three-dimensional forms and distance then some structural drawing is essential.'

Practise making marks for fun, and you will discover a repertory which might well come in handy when you wish to achieve a certain effect. On page 16 Clifford Bayly has made a simple landscape with foreground boulders made up of fingerprints and black ink blots, grasses and flowers with lightly dabbed rag soaked in ink, ink blots and fine pen strokes, and the middle distance by placing the paper on a rough stone surface and rubbing over it with a wax crayon. The trees are fingerprints again and black wax crayon — the hills beyond are created with small ink splashes and brush strokes of thinned ink.

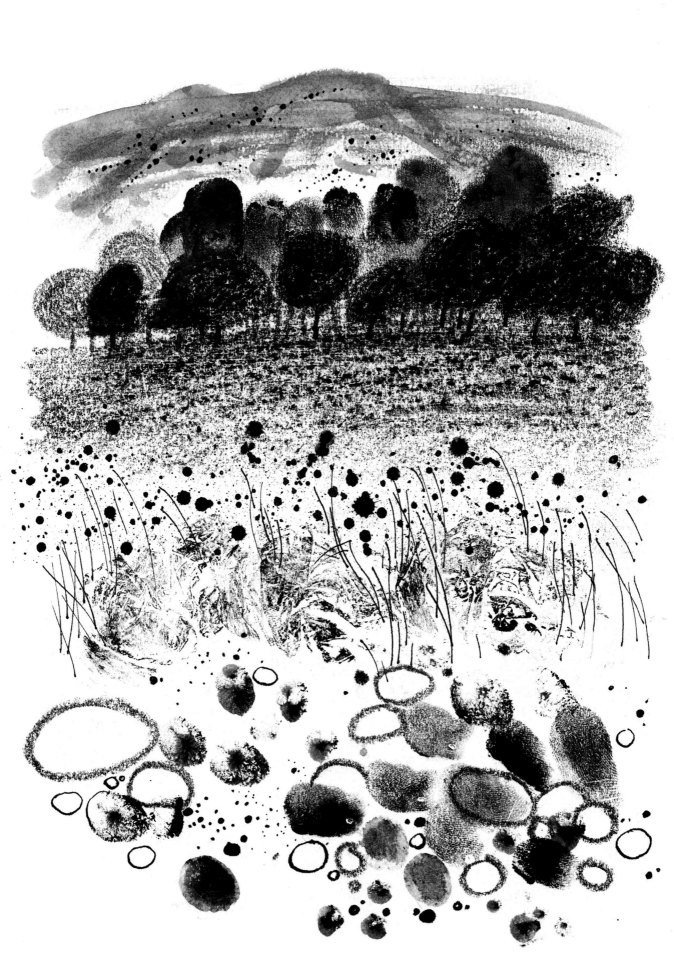

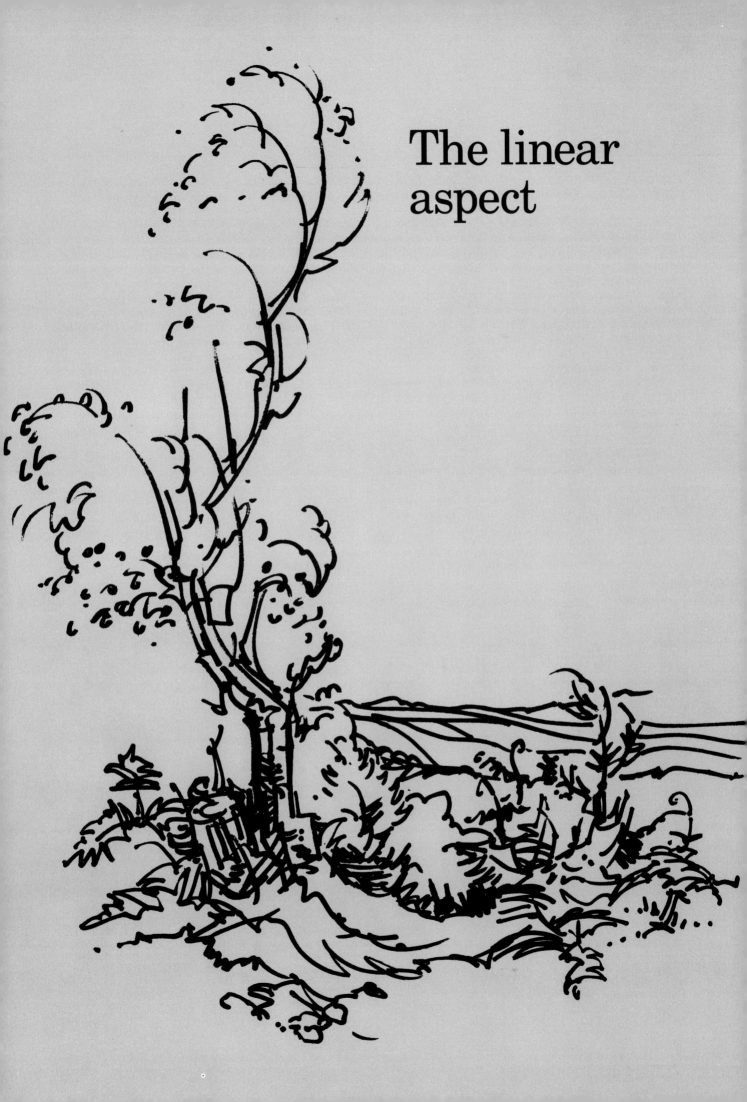

The linear
aspect

The linear aspect

The most commonly used and expressive mark in drawing is the line. Its simplest use is to define the edges of forms as we see them; in other words, their outer edges. A silhouette describes the boundary between light and dark without reference to form, yet it gives us basic information about that boundary. Extend the picture further by drawing in the edges within the silhouette and more information is revealed. Draw a house in silhouette, then add lines to describe roof, windows, doors. Finally draw in panes of glass, gutters, drainpipes, mouldings on doors, bricks, tiles; and the information is built up stage by stage until the house is described as a particular object. Such drawing can be referred to as informational or objective.

Take your drawing sheet again and draw one object in front of another in lines of equal weight. Now go over the lines of the object in front, making them darker — and immediately it will appear nearer, even if the object is smaller. This is a simple demonstration of the expressive power of lines.

Clifford Bayly adds, 'constructing forms on paper with line is a most valuable skill — I call it a skill because it can be learned; it has nothing to do with talent or depth of expressive feeling. Using lines to give an impression of solidity and space is just a matter of simple observation related to a few basic rules and optical laws, which can be learned quite easily. The secret of success is to observe and practise drawing rather than make intensive study of the rules — draw first and consult the rules only when you get into difficulties, or when your drawing does not turn out in the way you have perceived your subject.'

Once you have acquired the skill of observational drawing, start to use line to express feeling and movement. A simple line of equal weight throughout its length may have a descriptive purpose. An expressive line can be straight or flowing, scribbly or jagged, continuous or broken. It can describe form by following it rhythmically, it can express tone by cross-hatching, it can portray stillness or movement through its dynamic quality. Within a single stroke it can become thick and thin, heavy or light. Lines can flow alongside each other, cross, or stop dramatically, almost touching each other (think of the tension Michaelangelo created between the forefingers of God and Adam in the Sistine Chapel painting).

On these pages you will find several uses of observational, expressive and dynamic line, sometimes in combination, but all demonstrating many varieties of use to which line can be put.

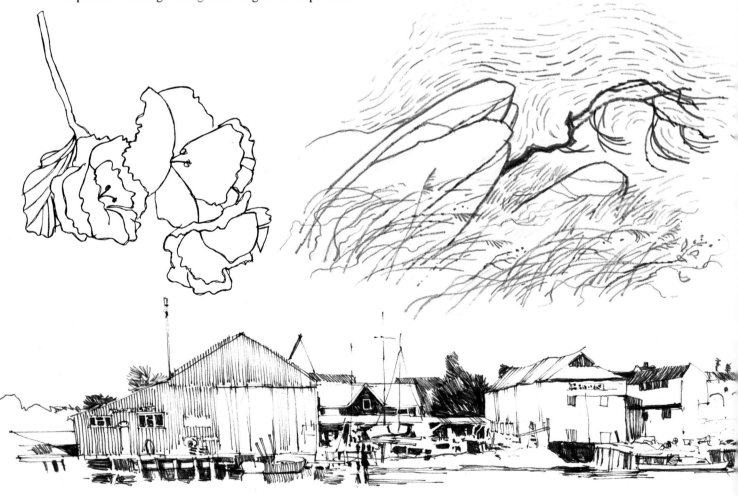

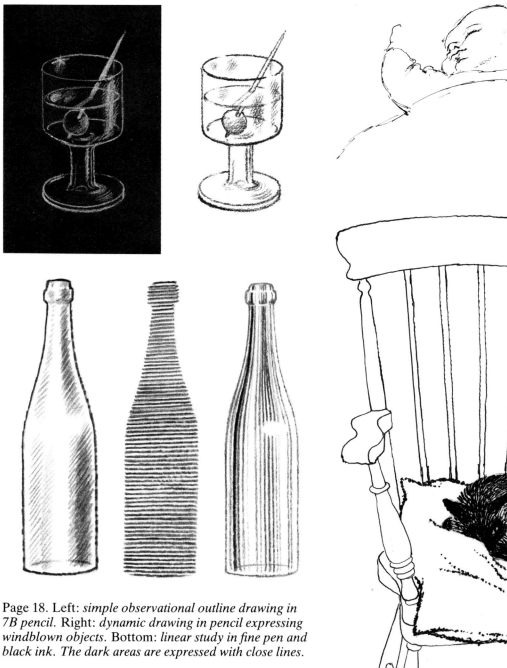

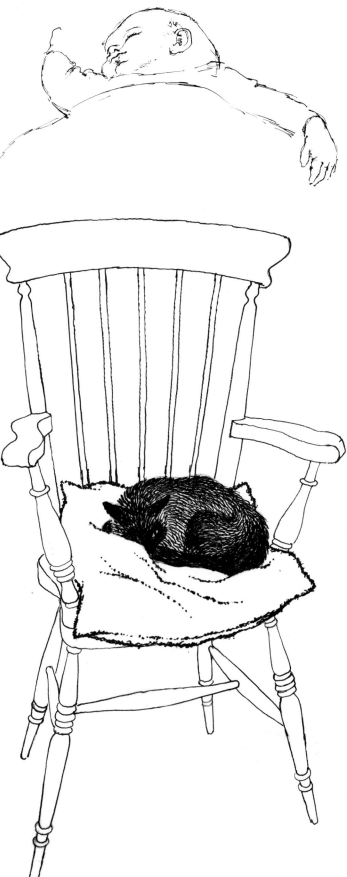

Page 18. Left: *simple observational outline drawing in 7B pencil.* Right: *dynamic drawing in pencil expressing windblown objects.* Bottom: *linear study in fine pen and black ink. The dark areas are expressed with close lines.*

Page 19. Top left: *white crayon on black paper and black crayon on rough-surfaced paper. Notice the variants in lighting the same object.* Middle, left: *bottles. Three observational studies using soft pencil line. The centre bottle is a silhouette. Try drawing the same object using different but purely linear techniques.* Top right: *sketch using flexible pen and black ink to give different weights of line within the same stroke.* Right: *observational pen and ink drawing using three qualities of line — pure outline, jagged line to express texture of cushion, heavy cross-hatched and contoured short lines to depict cat.*

Page 17. *Broad black felt tip marker gives dynamic line to express form of tree and landscape.*

Linear aspect

Top left: *speed. Bayly's use of wax crayon in intellectually controlled horizontal and dynamic lines deliberately blurs the observed cyclist to render the impression of speed and energy.* Middle left: *black ink applied freely with a brush on rough textured paper produces a silhouette of the potted plant, yet this drawing is linear in application and effect.* Top right: *nervous and sensitive broken lines capture an informal pose in this quickly executed fine pen and ink sketch. The mood is caught without faithful reference to form, although one feels its presence.* Middle right: *lines and marks. The tree, outlined in soft pencil serves as a foil for the black marks depicting small birds perching in its branches.* Bottom right: *dynamic and expressive lines combine in almost complete abandon to render more of a caricature than a portrait — yet one feels one would instinctively recognise the individual from this sketch were one to see him in the flesh.*

20

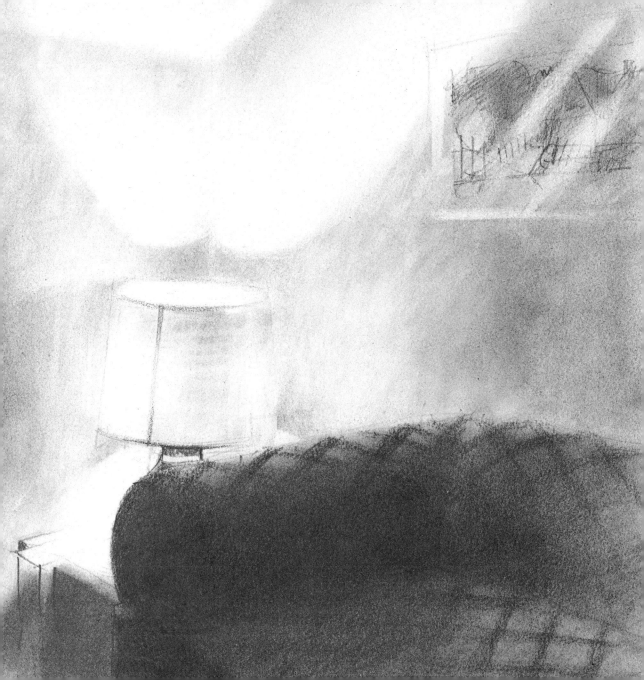

The tonal aspect

We have seen how line can build up our pictures. By adding tone we can create still further the illusion of three-dimensional form or enhance the mood and atmosphere. Tone is essentially the study and application of lights and darks. As we view our subjects in colour we must make a mental adjustment when depicting tone — transforming the colour into darks and lights, and observing within them highlight and shadow. If this seems confusing, look at your subject with your eyes screwed up — this reduces the effect of colour and detail, yet one can still see the tones.

The bottles on page 19 show how simple short strokes, or lines, can build up form. From such applications one can explore the whole range of tone-making. Another word for tone is shading, but that usually implies a dry medium. You can apply tone to a drawing by cross-hatching, by continuous tone in dry or wet medium, or both. On page 21 George Cayford has constructed a picture out of tones — there is scarcely a line in his drawing of an interior lit by lamplight. He uses graphite powder worked with his fingers and cotton buds, picking out highlights with putty rubber, and adding to them with white pastel. An extreme example perhaps, and not to be emulated until one has mastered the more conventional ways of drawing; but it makes its point, and the method is well suited to the subject.

Tone can be hard or soft, smooth or coarse. Within tone one can, by the way it is applied, describe textures — soft cat's fur, the naked shoulder of a woman, shiny leaves, the woven straw of a hat, or rusty metal.

The paper you choose will, however, have a significant effect on your drawing. Unless you are laying down washes of thinned ink to achieve tone, the grain or smoothness of the paper will reflect the mark you make upon it (see the sections on Materials and Marks).

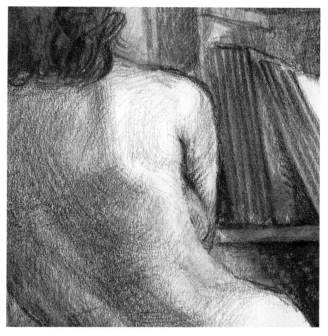

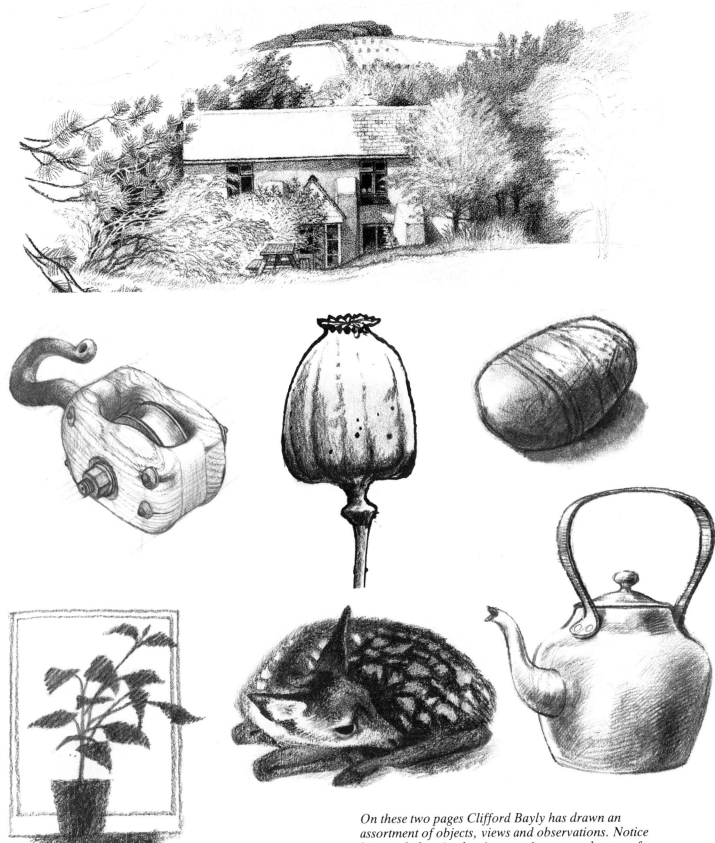

On these two pages Clifford Bayly has drawn an assortment of objects, views and observations. Notice how each drawing has its apposite tone and texture for stone, metal, flesh, straw, plant material, buildings, fur, wood.

Tonal aspect

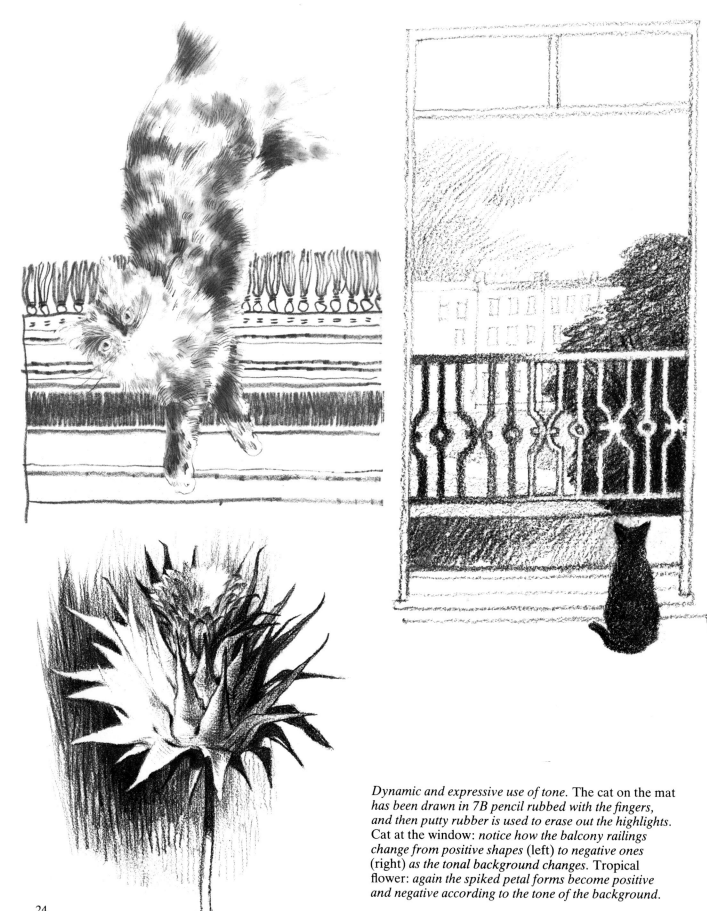

Dynamic and expressive use of tone. The cat on the mat *has been drawn in 7B pencil rubbed with the fingers, and then putty rubber is used to erase out the highlights.* Cat at the window: *notice how the balcony railings change from positive shapes* (left) *to negative ones* (right) *as the tonal background changes.* Tropical flower: *again the spiked petal forms become positive and negative according to the tone of the background.*

Still life and interiors

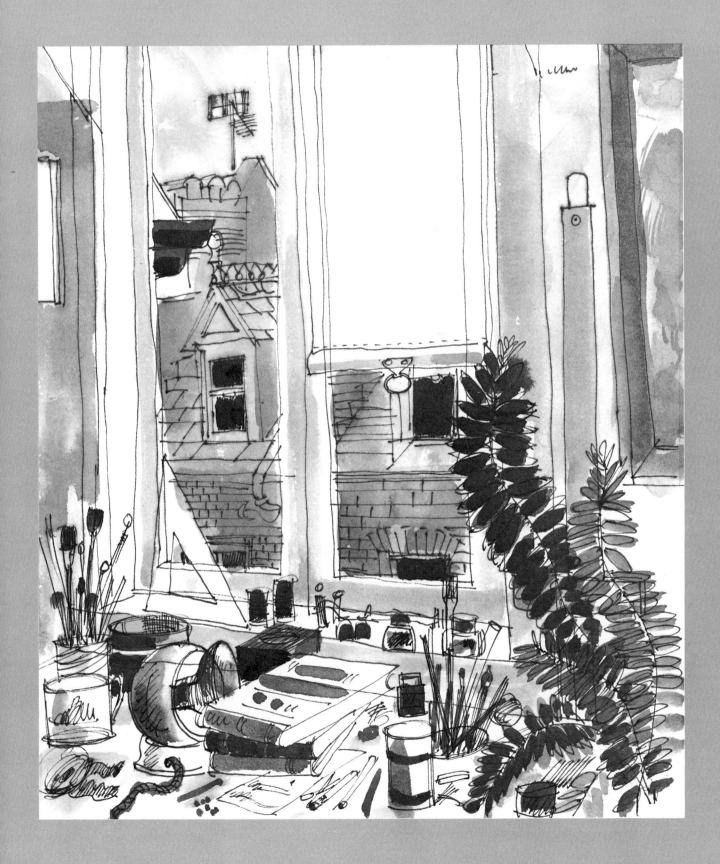

Still life and interiors

Applying marks, lines and tones together takes us into the realm of picture-making. Here we study objects in relationship to each other, or composition. A basic way of practising composition is to look around one's own home for objects that are related to each other by genre, i.e. fruit, vegetables, flowers; cups, bottles, jugs; kitchen utensils — or objects within groups that have contrasting shapes and textures, such as flowers and bottles, tablecloths and basins. Composing objects to make up a still life can be an aesthetic pleasure in itself, like flower arranging.

On these pages Clifford Bayly shows some of the salient elements that will help you to arrange still-life subjects, and to view them so that you will not only arrive at a composition which is pleasant to draw, but also interesting and possibly unusual. 'For your first attempts at still life,' he advises, 'use objects with simple basic forms and which are different in size and shape — tall, round, short, square, man-made as against natural or organic. Choose objects that, although different in form and texture, are related to each other in use or have associations, such as a season of the year.'

In the demonstration below, the plan (*middle left*) gives the arrangement of a few objects on a table. The line drawings above, below, and to the right of it all show those objects seen from different angles. 'Don't just sit down and start to draw,' Bayly adds. 'Take a careful look at the group from different positions — you'll find it will appear more balanced and pleasing from some viewpoints rather than others.

'Resist the temptation to move them about — *you* do the moving until you find which position will give you the best composition.' Bayly is telling you to practise by using the 'seeing eye', what George Cayford calls 'stalking the subject' (see pages 90–1). Quick sketches or visual note-taking will tell you whether you want to settle down to draw from a position — it need be only a few lines and quickly blocked in tones. Make several of these as you move around your still life, then contemplate them, eventually choosing the one you feel is the best.

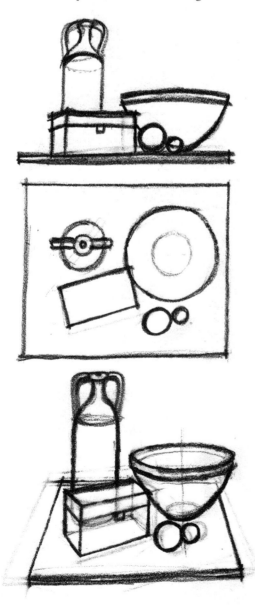

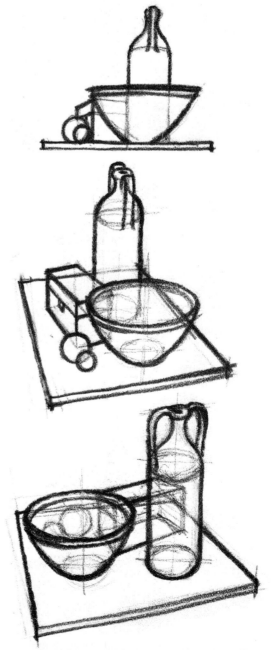

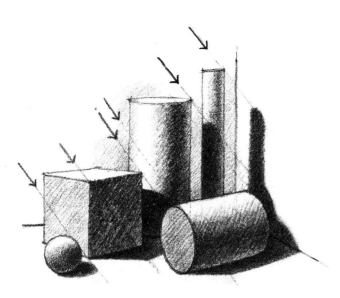

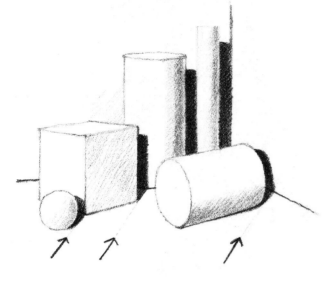

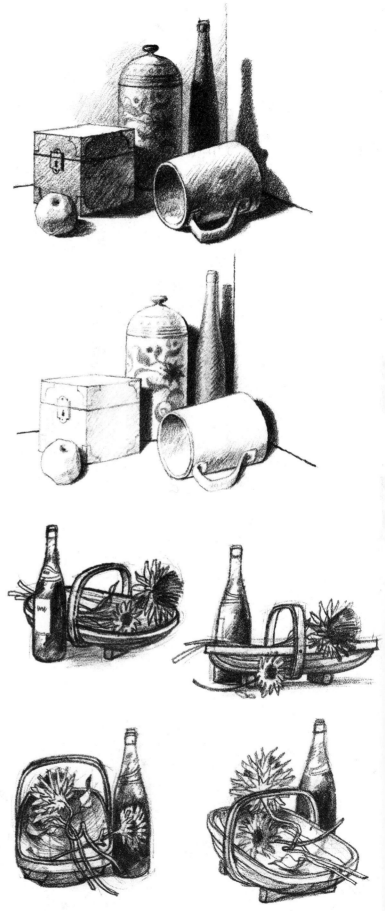

In the two pairs of drawings above, Clifford Bayly shows how lighting can affect the whole composition. Also he shows how still-life objects can be seen as blocks, cylinders, spheres and cones. Analysing basic shapes that form any object is a perceptive skill that requires practice only, not talent. 'Side lighting,' he says 'will offer you better opportunities to demonstrate form and solidity, for the modelling is stronger and texture shows to advantage. The nearer the group is to the light source the stronger the contrasts are between light and shade.'

To the right, Clifford Bayly takes a few simple objects of differing textures, and from *one* viewpoint moves them about to achieve four different compositions. Notice how in each demonstration the different objects overlap and relate to each other — compositional lines and shapes cut across each other. The overall silhouettes too are lively and not static. Look for all these aspects when arranging your own still-life drawing.

Still life

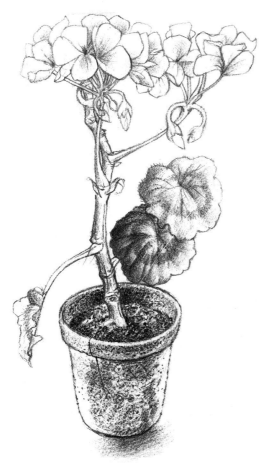

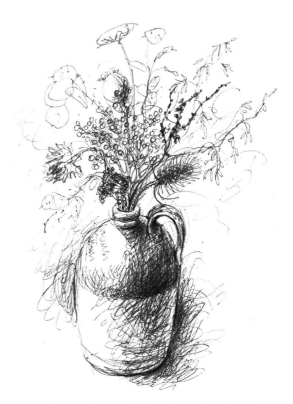

Some people tend, especially when drawing still-life subjects, to depict them in the centre of the page, and far too small. Be bold — extend your subject to the extreme edges, as in the sepia conté study below.

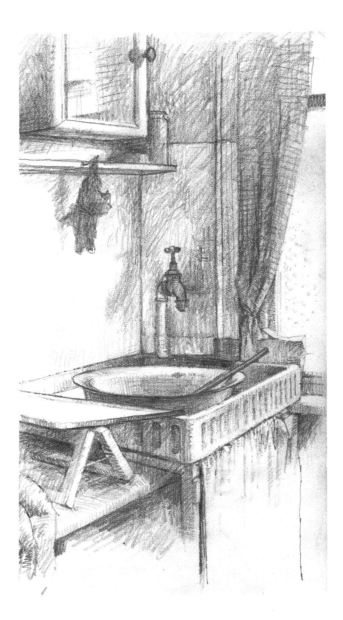

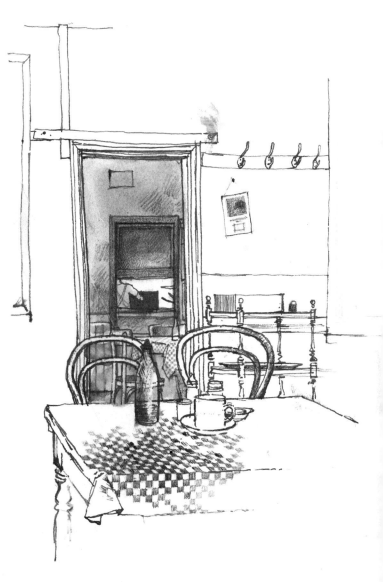

On page 28, top left and right, *are two very different sketches of plant material in pots. The geranium on the left is drawn in pencil and crayon; dried plant material is freely drawn in ball-point pen.*

There is something very satisfying about interior subjects. First, they are a glimpse into the lives of people, usually the artist's. Besides the sense of intimacy there is a reassuring quality about an interior study, representing as it does an air of permanency that a still life does not possess. On this page Clifford Bayly has chosen two studies, one as plebeian as a kitchen sink in a cottage with its single cold water tap, the other of rooms in a similar cottage. Soft pencil provides the tones for the sink study which was first drawn with a harder pencil. Notice how the shadow of the tap on the wall and the dangling dish-rag break up what would be an uninteresting flat surface.

In the sketch above, Bayly is depicting not only one room but another beyond through an open door *and* a glimpse of a figure working(?) outside the window. The whole picture is based on simple rectangles and squares relieved by the curved chairbacks and the crockery on the table. After first using soft pencil, he went over his drawing in black ink and controlled washes. Overleaf he illustrates how to approach the drawing of interiors.

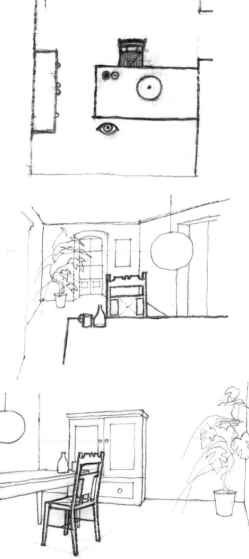

Drawing interiors

The way we place our possessions about our houses is often an expression of our personality — so what better subject could we have, or one more familiar, than the interior of one of our own rooms? But, as you begin walking around your living-room or bedroom, you will notice how perspective controls or even dominates what you see, with apparently converging lines where ceilings join walls, where the lines of door frames echo them, where the squared edges of tables 'angle off' to a vanishing point. Demonstrations of how perspective works are given in 'Buildings and Towns', pages 73–80. Here, although Clifford Bayly is using perspective, he is more concerned to show how, by moving about a room that is sparsely furnished and decorated, light from a single source (window or artificial) can determine your choice of viewpoint.

As in the demonstrations on still life, he first gives a room plan with a few pieces of furniture. The 'eyes' show the two viewpoints he selects. The two drawings on the bottom right of this page show in outline what he sees: a view from a standing position behind the table looking towards the window, the other from a sitting position looking across the room. On the left of page 31 he gives three tonal studies of these views: the top picture indicates the light source as coming from the window, the middle the same view by artificial light from the pendant lantern at night time. The same viewpoint — but how different the two pictures are in composition! The relative tones of walls, objects and shadows are completely changed although the linear aspect is the same in both. Notice in the picture of artificial light how the window catches the reflection of the lantern and, because the lantern is at eye level, how the picture glass reflects the light. The leaves of the house plant appear as silhouettes in daylight — in artificial light their shiny surfaces reflect it.

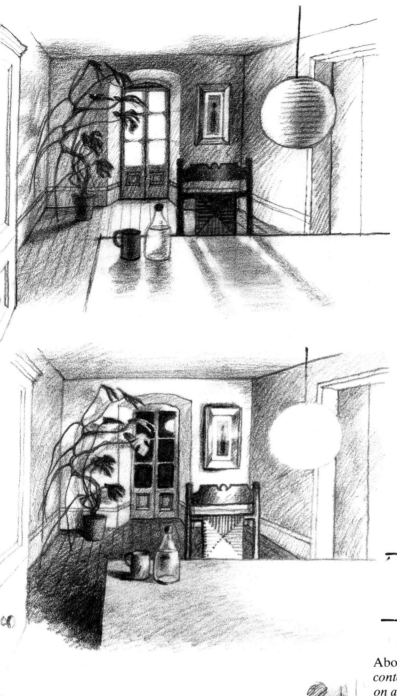

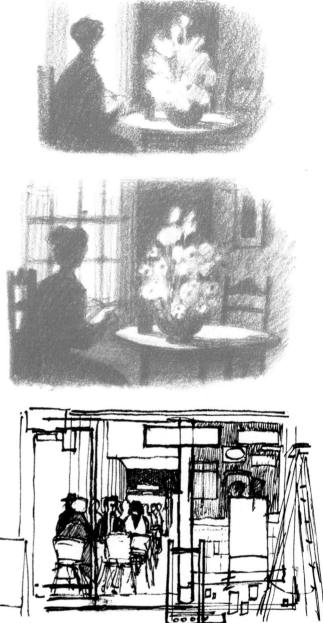

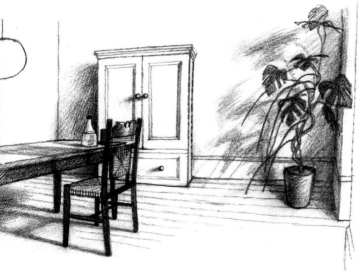

Above (top right): *two quick tonal sketches in sepia conté show dynamic use of silhouette and light falling on a vase of flowers.* Above. *A quick fountain pen sketch of an interior seen from the exterior — a café interior seen through its plate-glass window.*

On page 31 (*bottom*) the viewing point is close up against the side wall, the light from the window striking over the viewer's right shoulder from the window. Make such outline and tonal studies of interiors as you move slowly about your own room. Concentrate on the large masses, their shadows — above all, start by having a single light source — if you have more than one, close off all the sources except that which gives you the best potential for realising your drawing. Only when you have blocked in the main shapes, add detail. Even though his room is almost bare, Bayly's drawings have plenty of interest, achieved by careful observation of how the room is lit.

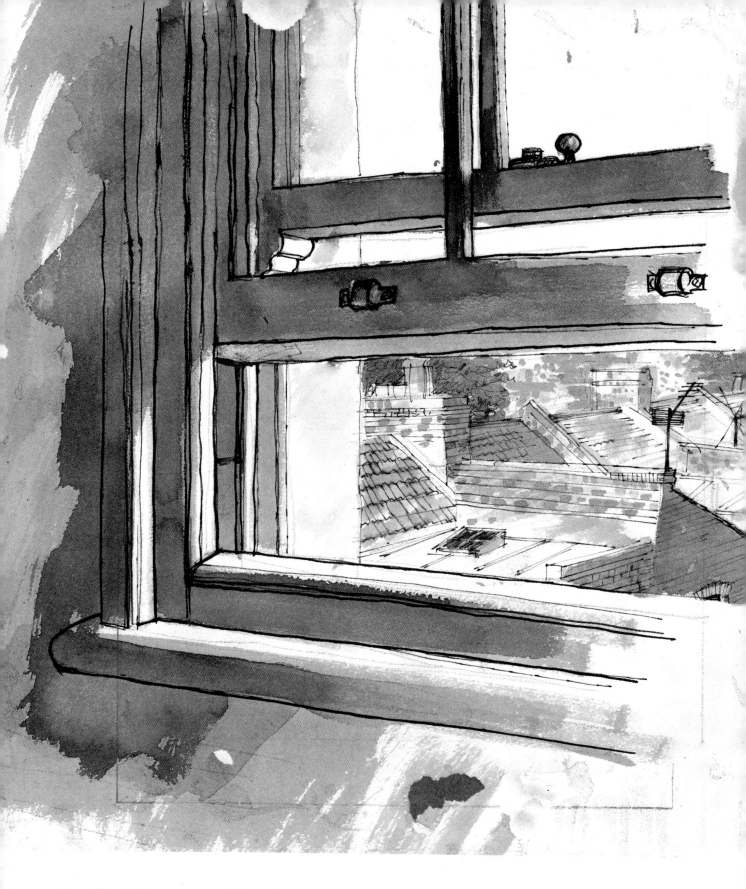

Page 25 and this page open and close the section on still-life interiors, with two drawings by George Cayford. The opening drawing, showing a corner of his studio, is both a still life and an interior, drawn loosely in fine felt-tip pen. He has then gone over it with loose washes of diluted black ink of various strengths applied with a brush.

On this page the drawing, first outlined in pencil, is then drawn in with a thick variable pen nib. Other parts of the picture (the view) are drawn with a fine nib and ink. When the various washes which build up the tones are dry, touches of white pastel crayon are added to the window frame on the right and to the highlights on the window catches. This geometrical view anticipates the section on Buildings.

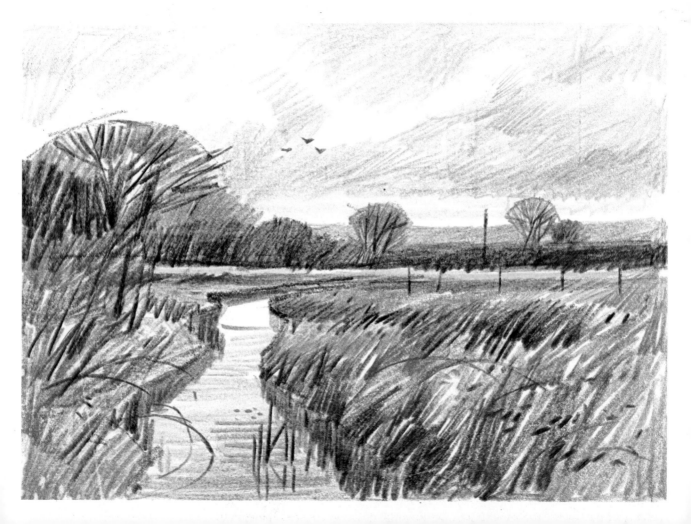

Using colour

Nowadays, the range of materials available for drawing in colour is almost endless. From blackboard chalks in the schoolroom to felt tip pens and markers for designers, coloured papers of all hues and colours — the choice can be bewildering.

When starting to draw most people think of two main colouring mediums: watercolour and pastel. These are certainly the most commonly used by artists, and there are societies devoted to each. But, for many years now, other mediums have come onto the market, and while there are purists who scorn them other artists have been quick to see their potential. Coloured ballpoint pens and markers are widely used in offices, and nearly every child has his or her own wallet of coloured crayons or felt tip pens to take to school or for drawing at home. When you start to draw in colour, begin by acquiring a simple selection of coloured pens and crayons available at any stationers and try them out for yourself before you enter the Aladdin's cave of the art shop or designers' supplies.

George Cayford adds, 'most of us when drawing for pleasure are not worried or concerned with purist theories — it's the end-result that matters'.

In the following pages our contributing artists show, in their drawings and demonstrations, a few of the ways in which they use colour, sometimes with simple pencil and crayon, at other times mixing the mediums or drawing directly onto the paper.

Once again we start with making marks, but now we have the added interest and excitement of colour. Copy the marks on the opposite page in the same way, using your own crayons, pastels or felt tips. Try using them on rough or smooth paper. Notice the difference between 'dry' mediums and 'wet' mediums — pastels, conté, charcoal, crayons are dry (some can be loosened with water) whereas felt tip pens and markers, inks and watercolours are wet. Each makes its own characteristic mark, line or blob. Notice too, how coloured papers affect the marks — 'cool' papers tone down warm colours applied to them, and vice versa.

But remember, such experimentation is only the vocabulary of drawing in colour — the grammar and syntax are how you use them to produce the drawing you thought about and set out to accomplish.

From top to bottom:
Top: *water soluble felt tip pen loosened with a brush and clean water wash.*
Middle: *a blue watercolour wash has been left to dry, then oil pastel drawn over it.*
Bottom: *lines of masking fluid are drawn on the blank paper. When dry, a red watercolour wash is laid over them. When it, too, is dry the whole area is rubbed gently with a finger which lifts the masking fluid to leave the white paper as lines.*

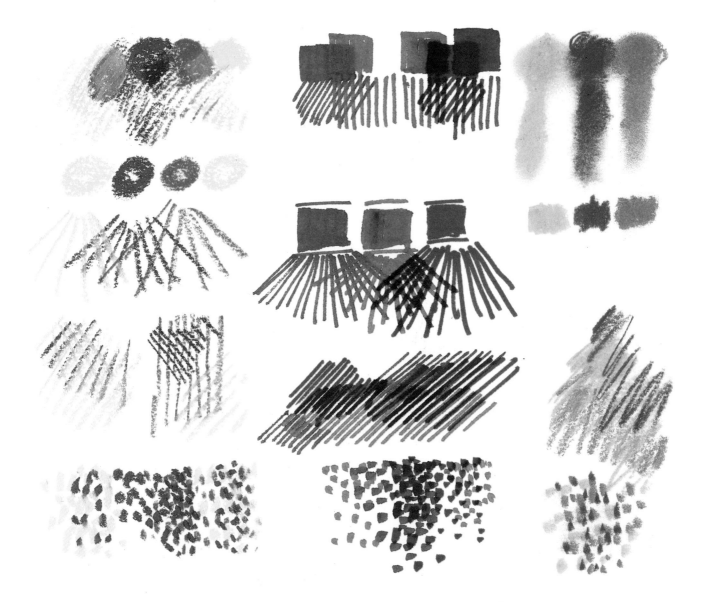

Above left: *various marks and shades made by oil pastel.*
Middle: *felt tip and layout markers. Notice how different the cross-hatching is from that of the oil pastel. Felt marker colour sinks into the paper immediately, leaving a rather hard, inflexible line or mark without subtlety.*

Right: *ordinary pastel. This can be rubbed into the paper with the finger or a stump of paper, giving beautiful soft effects and graduations.*
Below: *marks made on different coloured papers with coloured felt tips and chalks.*

Crumpled paper and bandanna

George Cayford says, 'Objects in a still life do not have to be spectacular or 'important'. Here, I was interested in the contrast of textures between the crumpled paper and the soft folds of the cloth, and chose to drop them, quite casually, onto a flat neutral surface. In the demonstration (*above*) I have broken down the picture into numbered bands to show how I tackled it.'

Stage 1

I first draw in the main volumes, outlines and shapes of the objects in soluble felt tip pens, carefully choosing colours nearest to the subject — in this case red and blue. By taking this bold and direct approach I make a positive statement very early on which gives me a definitive reference when building up the picture.

Stage 2

I then apply watercolour and thin washes to establish the tonal values of my picture. Notice how the strong initial lines of the felt tip pen drawing 'bleed' and soften, yet

are still visible. Where I want to lighten the picture I go over the now dried watercolour with clean water and a brush, loosening the paint, and then blot it with blotting paper until I have achieved the right hue and tone.

Stage 3

When the picture is thoroughly dry I then add blocked-in shadows with watercolour and let them dry. Finally I add white opaque ink to the details of the bandanna and reinforce the crispness of the paper with pen and black waterproof ink — also in the shadow areas.

The finished painting

You can see how, by looking *first* at your subject before you start to paint it, you can analyse and determine what mediums you can use. In this picture I have used soluble felt tip pens, watercolour and black and white inks.

Using colour

A quick black-and-white sketch by Norman Battershill, done with a felt tip pen. 'I made no attempt to capture tone — the masses and directional lines interested me but I discarded this view as being too regular.'

Below: *black carbon pencil on tinted paper. 'A corner of an old barn that I eventually went back to later,' writes Norman Battershill. 'It is not always necessary to have a particular point of interest in your composition — here the barn, fence and brick wall in the foreground, while not competing with each other, all have their pictorial value.'*

River Scene

Obviously, when we go outdoor sketching, we cannot take all the paraphernalia of our studio with us. In contrast to the demonstration on the previous pages, therefore, Norman Battershill took with him just a felt tip pen, black carbon pencil, and coloured crayons to make preliminary sketches of the subjects that interested him before he spotted the small river which makes up this landscape demonstration. Some of the sketches on these two pages are records of what he saw and pleased him — much more satisfactory than taking photographs! — for by actually drawing what he saw he was practising his art and his mind's eye was sharpened to the subjects. When sketching out-of-doors bring to your 'seeing eye' the same faculties as you do when sketching and drawing about the house — select and sort out the details and masses that give you a good composition. Move slowly, turning about you frequently — what you have just passed looks entirely different from when you approached it. Sit down and contemplate, watching the sky's effect on the landscape — sunlight and shadow can change dramatically what at first seemed quite ordinary.

In this demonstration Battershill uses carbon pencil and crayons on ordinary cartridge paper. This is how he describes the way he built up his picture:

Stage 1

The main shapes of this landscape subject are drawn in first with soft carbon pencil. It is a simple composition in which the river is the main point of interest.

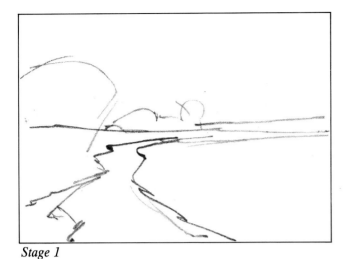
Stage 1

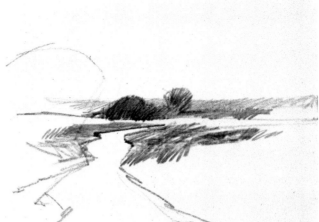
Stage 2

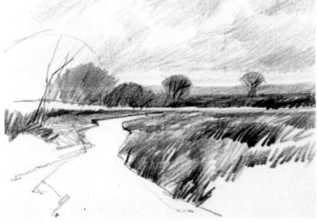
Stage 3

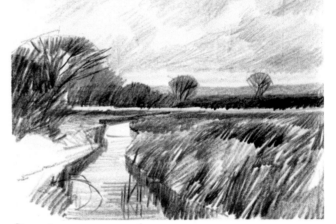
Stage 4

Stage 2

Overlaying colours with crayon pencils can produce interesting colour combinations, such as yellow over blue, red over yellow and blue over red. Notice how the river winds towards the centre of the drawing and forms the focal point. If the river went towards the edge of the picture your interest would be attracted away from the focal point.

Stage 3

I soften and blend the colours towards the horizon because this helps to give a feeling of recession to the landscape. The distant trees balance the left-hand side of the composition.

Stage 4

If you use a black crayon lightly over another colour, as I have done along the line of the distant hedge, it makes it darker but you can still see some of the colour underneath.

Right: on his way home Norman Battershill did this little sketch in charcoal, rubbing it softly all over the page before drawing in the few details that make up the subject.

Stage 5 — the finished drawing
(*reproduced on page 33*)

Accents with black crayon sharpen up the sketch, but there is a danger, if I overdo this, that the drawing will become too dark. Notice that all the crayon marks here are bold and direct, because that gives a feeling of spontaneity to the drawing.

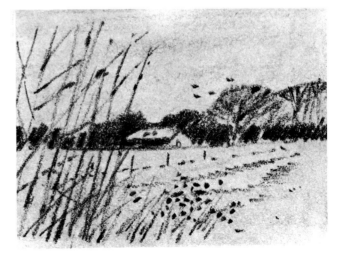

Felt tip and marker pens

As you will have seen on pages 34 and 35, coloured felt tip pens and markers make vivid and attractive drawing mediums. Some are water soluble (they can be thinned and spread over the paper with a brush and clean watercolour), othes are permanent. Because they sink into the paper immediately they are applied, penetrating the paper fibres and staining them, they are not very suitable for use on layout pad paper or other thin, soft-textured supports. The best ordinary paper to use is cartridge with a smooth finish, as the marks which felt tips make are not capable of great subtlety. However, once you feel confident of your ability to 'construct' a drawing in pen or pencil, explore the more direct, dramatic qualities of felt tips. Take a felt tip and move it slowly over the paper. Notice how it leaves a dense, even mark. Now make the same mark very quickly and lightly — you will see that it leaves less ink on the paper, achieving a lighter hue (or in the case of black, a lighter

tone). Practise these techniques until you are thoroughly used to the effect of 'speed' in applying your marks and lines. In fact most felt tip drawings have an air of immediacy about them — very rarely can you achieve a considered, studied effect.

Of the two colour sketches made by Battershill (*opposite*) he says: 'I like the clarity of colour that felt tip pens offer. Also the colours can be overlaid with interesting effect. You may prefer to pencil in your subject first but do also try to work direct with the pens.

'There is a wide range of colours available in felt tip pens. In the second drawing I used the seven colours indicated plus black, which is a good basis for you to begin with. Bear in mind, though, that some colours, particularly the paler ones, may fade or change colour in time.

'Marker pens are inexpensive and easily available at most stationery and art shops. Because of their chisel shape, and the broader mark they make compared to other pens, they are much more fun to use, and more expressive. If they do not have permanent ink, however, the colours may fade and change.'

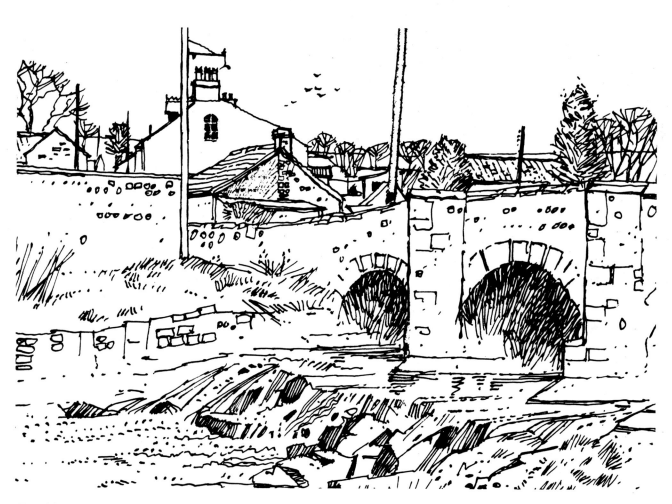

Fine felt tip pen on cartridge paper.

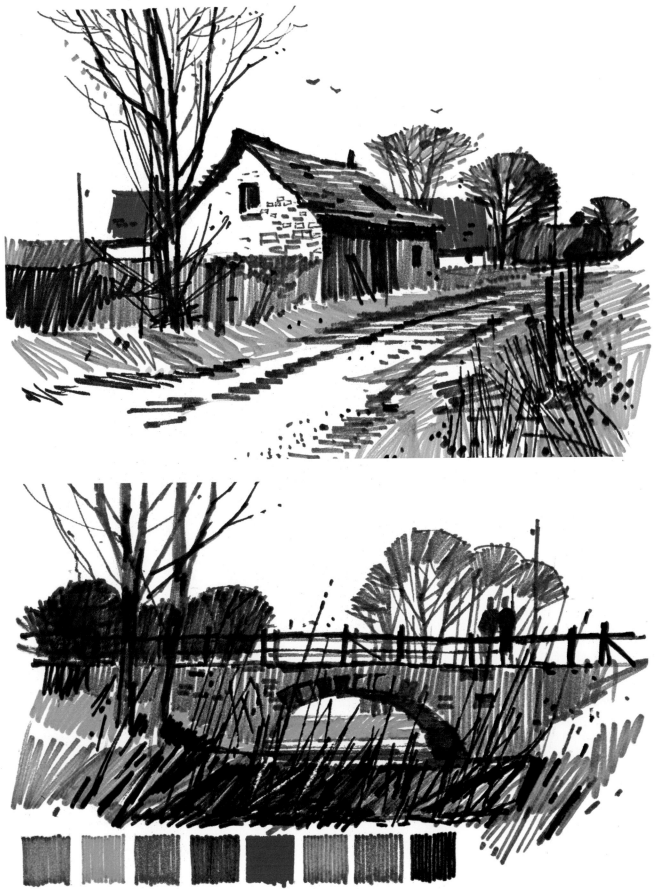

Pastel

Pastels come in several forms: in sticks or bound with wood as in pastel crayons. The pigment that constitutes the colour is bound together either by gum tragacanth (dry ordinary pastel), or by a wax, as in oil pastel.

Drawing in pastel can produce lines and marks unlike any other medium, offering subtle tones and colours that are dense and sparkling. They are best used on papers that have a grain or 'tooth', such as sugar paper or Ingres paper — both of these come in many colours, they provide interesting backgrounds to work on which show through the applied pastel, and give a luminous quality to drawings done in this way. In dry pastel, the range of colours and hues obtainable is enormous and when one is starting one apparently can get quite carried away by the infinite range that artists' shops carry. Confine yourself, to start with, by buying a set in a box — just a dozen sticks will suffice. Try picture-making with them — you will find you can obtain most effective results. You will find too that the earth colours are harder in texture than the primary tints, which tend to break if pressed too hard. One artist I know strips off all the papers around his pastels, preferring to pick up each one as he draws by its actual colour, not the description on the paper.

To make a fine drawing point, sharpen pastels carefully to a rough point with a knife, finishing off on sandpaper. To get blocks of colour, hold a broken piece of pastel sideways, dragging it across the surface of the paper. You can also rub the pastel into the grain of the paper, spreading it with your finger. Your tools, in fact, are the pastel itself, your fingers, and putty rubber which will lift some of the pastel on the paper when you press it firmly onto the part you wish to lighten or erase. Blow excess pastel chalk from your drawing, otherwise it will become caught up in subsequent strokes.

You will find that the pressure you apply with the stick on the paper will affect your work. Try making simple strokes of varying pressure with one tint or colour, then cross-hatch it with another colour, using the same degree of pressure; you will see how the delightful vibratory colour effect is achieved — the unique quality of this exciting medium.

Above (top): *a half-finished pastel drawing by Dennis Frost, and a detail from the finished picture showing how the grain of the paper affected the marks he made. You can see where he dragged the colour sticks on their side — notice too in the detail where he pressed his stick hard on the paper in the highlights. These are good examples of how pastel can be used at its most effective.*

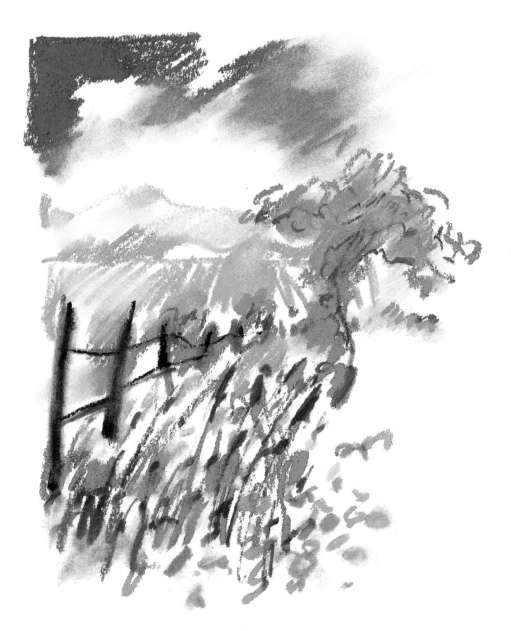

Oil pastel: *in the sketch above, George Cayford
displays the harder qualities of oil pastel, which cannot
be rubbed with the finger. How, then, did he get the
lesser hues and shades? 'Oil pastel can be loosened and
spread on the paper with white spirit, which dissolves
the wax and releases the pigment. In the drawing I used
a brush in white spirit; in the colour chart* (bottom right)
*I dabbed at the marks with cotton wool soaked in white
spirit. But remember to use a heavy paper for this
technique, otherwise the spirit will soak in and spread,
spoiling your drawing.'*

Using colour

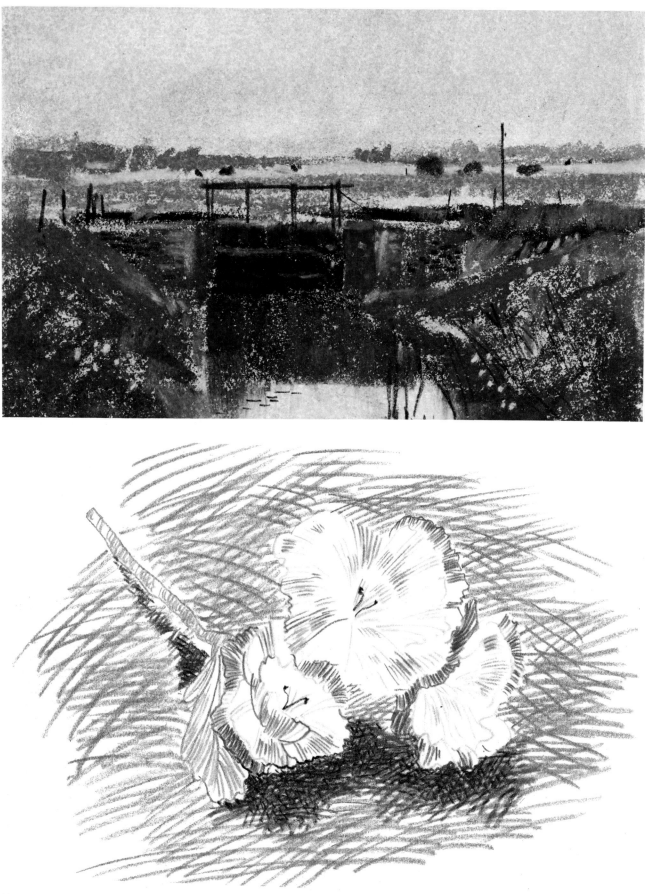

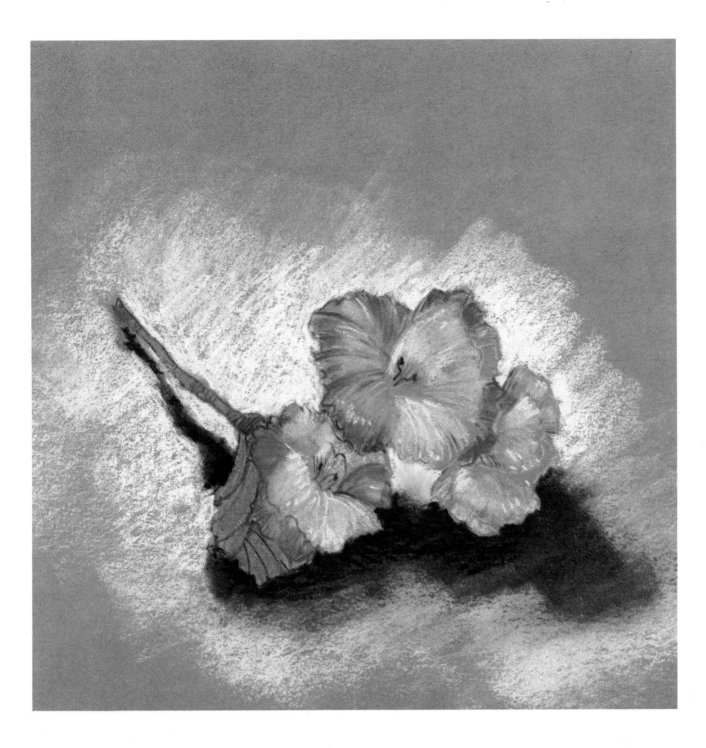

Page 44 (top): *Battershill's pastel picture (reproduced here in black and white) illustrates very well the graininess of the paper, and how he has used it effectively to obtain a vibrant quality by keeping his pastel strokes and marks definite. In places he has rubbed the surface, but sparingly.*

Page 44 (below): *in contrast, Cayford has drawn these artificial flowers in pastel pencil, fixing each colour as he finished applying it, before moving on to the next, darker colour. In this way he has captured their crisp quality. It takes a lot of pictorial analysis beforehand to proceed in this way — but that is one of the advantages of constant practice.*
Above: *the same subject, the same artist, but this time soft pastel on brown sugar paper. The contrast between pastel pencil and soft pastel could scarcely be made more apparent. Coloured papers with a rough texture allow the artist to use pure white pastel most effectively.*

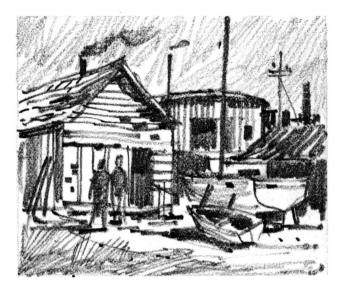

Pen and watercolour

Where sea meets land has always been a favourite subject for artists, and harbours and boatyards provide a wealth of such picturesque material. Norman Battershill wandered over the foreshore making many preliminary sketches in carbon pencil before he came across the particular view which makes up his demonstration painting *The Boatyard*. He writes: 'Drawing directly with a pen develops confidence and sureness of hand. I begin this sketch therefore without any preliminaries, using a needlepoint pen and black waterproof ink.

'After establishing the main shape of the shed I start putting in the details of boats and planks on the beach. Notice that my shading lines are open so that colour will show. Further pen work can always be added later. My main concern here is to create light and dark tones to give contrast, for example between the sunlit side and the shadow side of the boat shed.

'I add broad splashes of watercolour. When colours are painted wet into wet they blend into each other. In this case, the colour and the textured paper give a weathered appearance to the boat shed. I enjoy this kind of subject, for the boats and buildings provide many different textures. The pen and the wash in this drawing should be evenly balanced without either becoming predominant. At the same time the contrast of light and dark is vital; but after adding a little more detail I decide to stop before the drawing becomes overworked.'

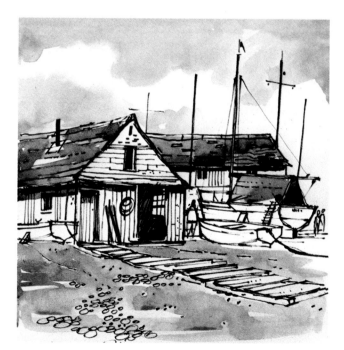

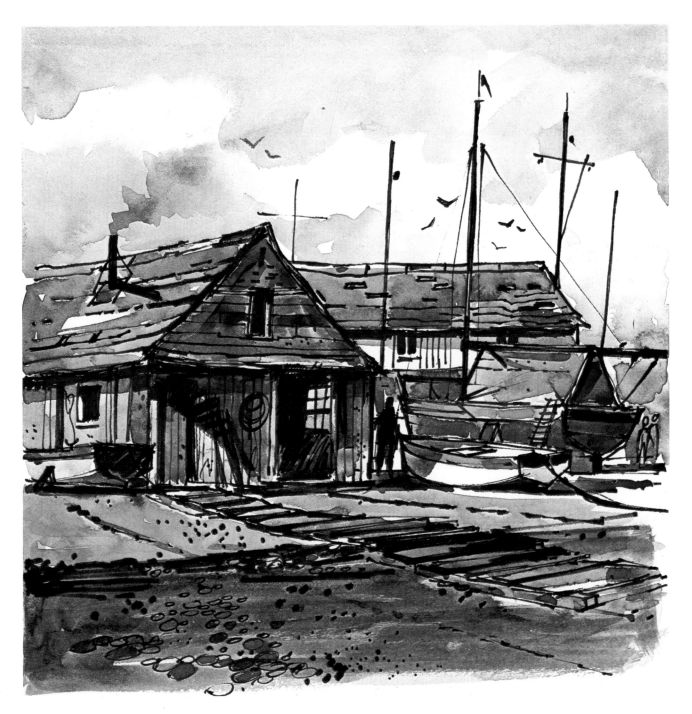

In this picture Battershill lets the white paper do a lot of the work — in the sky, on the buildings and on the boat in the middle foreground. When you use pure watercolour washes, keep them simple — the more you lay one on another the muddier the effect will be — as in the foreground of this picture, where it is intentional!

Using colour

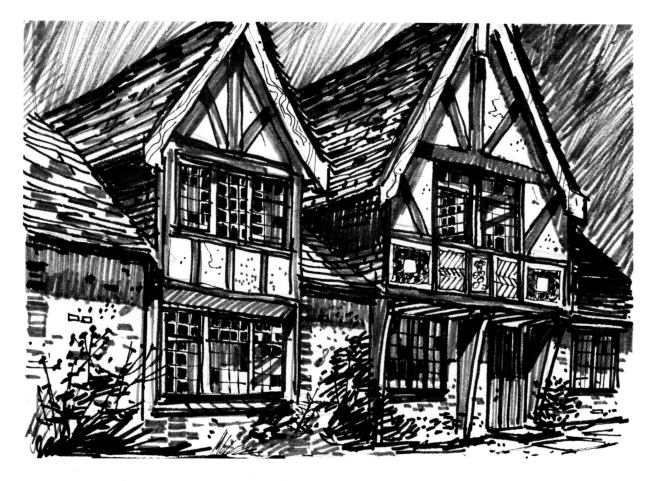

One must not forget that blacks and greys can constitute 'colour' in an artist's vocabulary. In this drawing (above) Battershill employs black and grey felt tip pens to draw old half-timbered houses. By drawing in the main outlines and hard details of the buildings he gave himself a framework on which to add the tones in the grey felt tip — look how the sky, quickly shaded in with grey, throws the buildings forward. When he had achieved the overall tones he went over his drawing again with black, putting in the detail as well as blacking in the leaded windows.

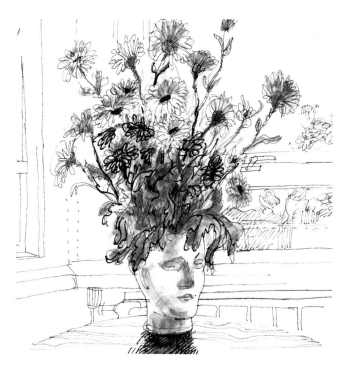

Cayford's drawing of flowers in an amusing vase (right) was executed with fine needlepoint pen, broad nib pen and black ink, and washes of diluted ink applied with a brush. When drawing with the fine needlepoint it seems as though he never lifted his pen from the paper — which underlines how one should spend more time looking at the subject than at the drawing — if you practise enough you will find your hand will obey your eye without having constantly to watch what you are doing. One of the reasons many actors portraying artists on television or in films are so unconvincing is that they spend their time looking at what they are doing and not at their subject!

48

Landscape

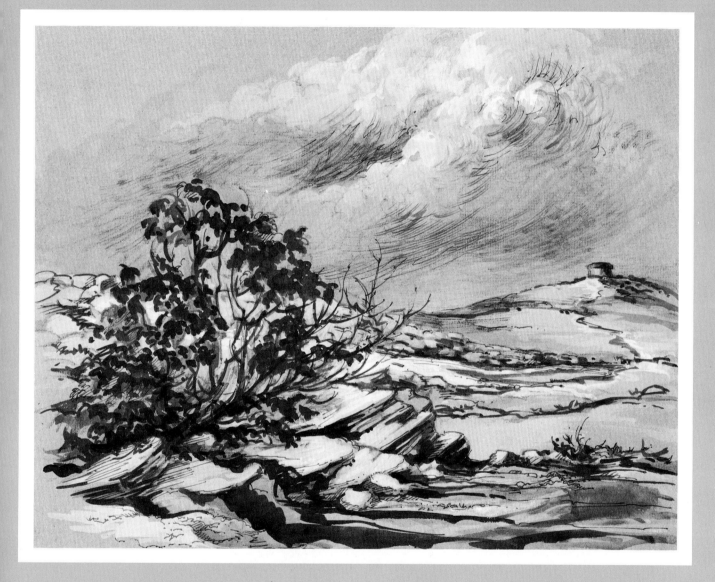

Drawing landscape

If we judge by the number of images, whether created by artists or by the camera, that appear in exhibitions or periodicals, landscape is the most popular subject we choose to look at. Maybe that is because most of us live in towns — there is something refreshingly 'escapist' about the rural scene, and 'a weekend in the country' is what many of us dream about and only occasionally achieve. Such opportunities present the artist with a never-ending source of subject-matter, from the vast panoramas to the intimate details of trees, plants and flowers. Margaret Merritt writes:

'The movement of sky and ever-changing light demands a flexible attitude to technique when depicting landscapes, and we have to cultivate not only speed but a range of approaches to drawing to help us translate what we see into a sketch, picture or study.

'Many people use photographs to draw from in preference to working out-of-doors. Interesting work can be produced in this way, but for many of us the act of drawing outside in all weathers gives much greater satisfaction and interest.

'The vitality of a drawing depends on our spontaneous reactions to what we see. Our interest and feelings unite us to our subject and this gives our drawing life and meaning.

'Some artists develop sketches into highly polished drawings, others use them as the basis for painting. Whatever our motive for drawing, the materials we use must be understood and used with ease and confidence.'

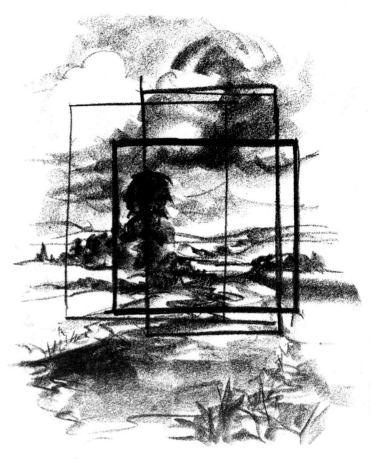

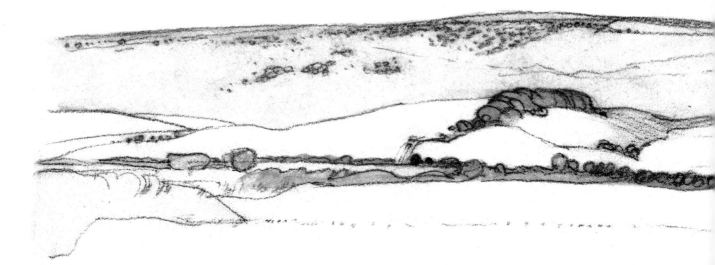

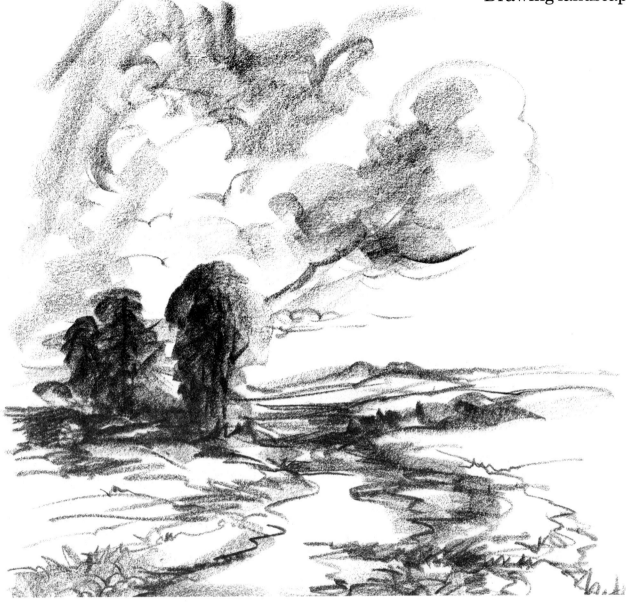

The two sketches on page 50 (left) *show how Margaret Merritt has set herself to solve the problem of composing a simple landscape. From the roughest of sketches in carbon crayon* (left, above) *she draws approximate rectangles and squares over it like windows to determine the most satisfactory composition.*

Below (left) *she makes another simple drawing of the one most heavily marked, then finally she compromises with the most finished sketch* (above). *Do not worry about wasting paper — make as many sketches as you need to find the composition you want.*

Below, across both pages, is a downland sketch by Clifford Bayly.

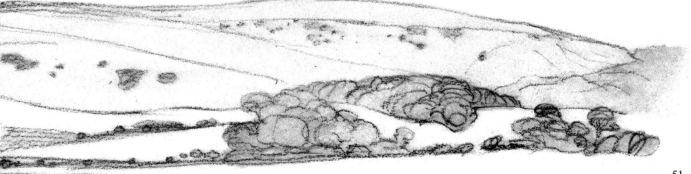

Composing landscapes

Margaret Merritt writes: 'Composition sometimes causes confusion amongst beginners who say "I drew it like that because it was there". By "composition" we mean how we organise and design a picture in relation to the space available.

'Composition must be determined by what we want to depict or illustrate in our painting. It is important to consider mood, atmosphere and impact. A well-composed drawing is inviting to the eye. Every space or shape represents *something*. We call these shapes *positive* and *negative* space. The positive shapes are the objects in the landscape, the negative space being the spaces between them. Composition is how these two kinds of space are interwoven.

'How large do we make a tree? How much space do we devote to the sky? To the left, I have composed the same subject three times, giving attention to different aspects of the landscape. Through composition we give attention first to the most important features, and then to the areas of secondary interest. Remember, the eye must not be led out of the picture before it has been on a guided tour within it.

'As I draw, I try to take account of the following danger zones in the "picture space":
'*Corners* are natural arrows pointing out of the picture. Redirect the eye away from these natural exits. *Edges* are the frame. If we emphasize them too much they draw attention to themselves and detract from the major areas of interest. Avoid putting shapes and details along edges. *The centre* is a fixed and automatic resting place for the eye which can be hypnotized into remaining there. Lead the eye beyond and around this area so that the picture may be seen as a whole.

'Notice the river scene re-composed *without* attention given to the danger zones! I list a few other dangers to consider:
'*Don't* cut your picture into equal proportions. *Don't* draw shapes which abut, as this *flattens* the picture. *Don't* repeat the same kind of shapes without variation of scale. *Don't* forget we need to emphasize the focal point, or area of dominant interest.

'To turn to the positive, creative aspects of composition:
'*Contrasts* of all kinds are important. If we wish to communicate largeness put something small near it. Contrast light with dark, thick with thin, etc. *Balance* implies distribution of tonal *weight*. Check your composition and ensure an harmonious whole. If attention is drawn to one side only, the picture will be out of balance. *Rhythm* holds the picture together — like a tree by its branches. Shapes brought together create lines which run from one part of the drawing to another, creating rhythms. These can excite or soothe, but should not be so wild as to distract, nor so monotonous as to become boring.'

Above: *corners, edges and the centre.*

Above: *example of poor composition. The shapes are too regular, there are distractions at the corners, the horizon is central.*

Above, *right: rhythmic lines in felt tip pen vitalise an otherwise quite simple scene.*

Landscape

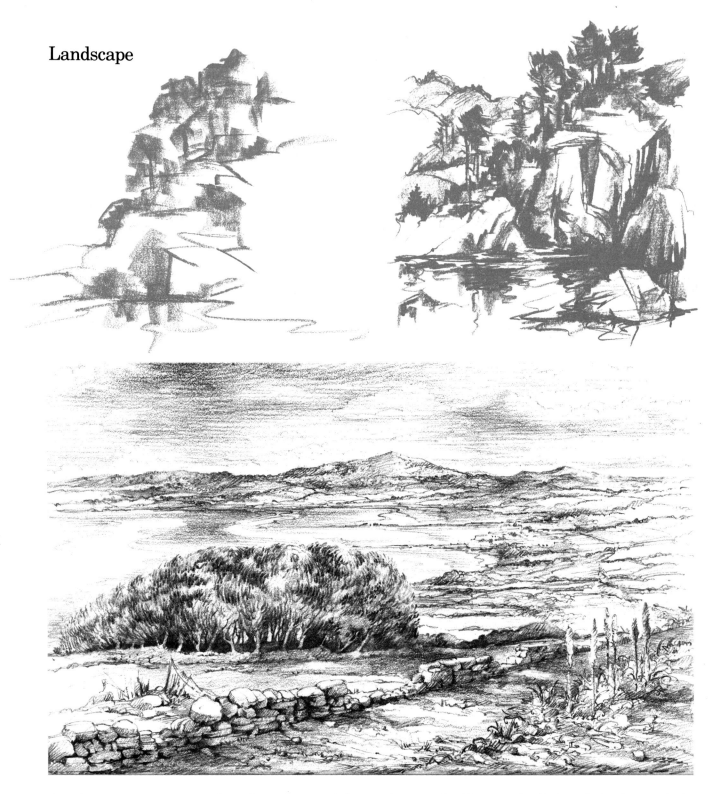

On these two pages several mediums are used in depicting landscape. *Top*: Margaret Merritt has chosen sepia conté in a stick to show in two stages how she builds up a picture of a rocky coastline on the Mediterranean. By breaking the stick into a shorter length, she blocks in the main tonal values, using the side of the conté stick, and then adds details and contours afterwards. Conté is very useful for quick tonal effects — by dragging the side of the stick one gets a 'block' of tone. The details are then added in boldly with the edge of the conté stick. Using conté in this way one can obtain an infinite number of marks and lines. It is thus a very satisfactory medium to work in, but it needs a confident approach as it cannot be erased. *Above*: a detailed study in 6B pencil, by Margaret Merritt, of a Minorcan landscape. Notice the variety of tone and line. *Page 55, top*: an expressive study in evening light of a rocky landscape with an old fort. Margaret Merritt has chosen grey Ingres paper, first drawing with 6B pencil, then with flexible pen and black ink, finally laying on thin washes of white paint and picking out the highlights with thicker white. *Below*: Clifford Bayly's study of the Downs is drawn on watercolour paper in soft pencil. Black ink washes of various dilutions were applied afterwards. Notice how the foreground plants give scale and interest.

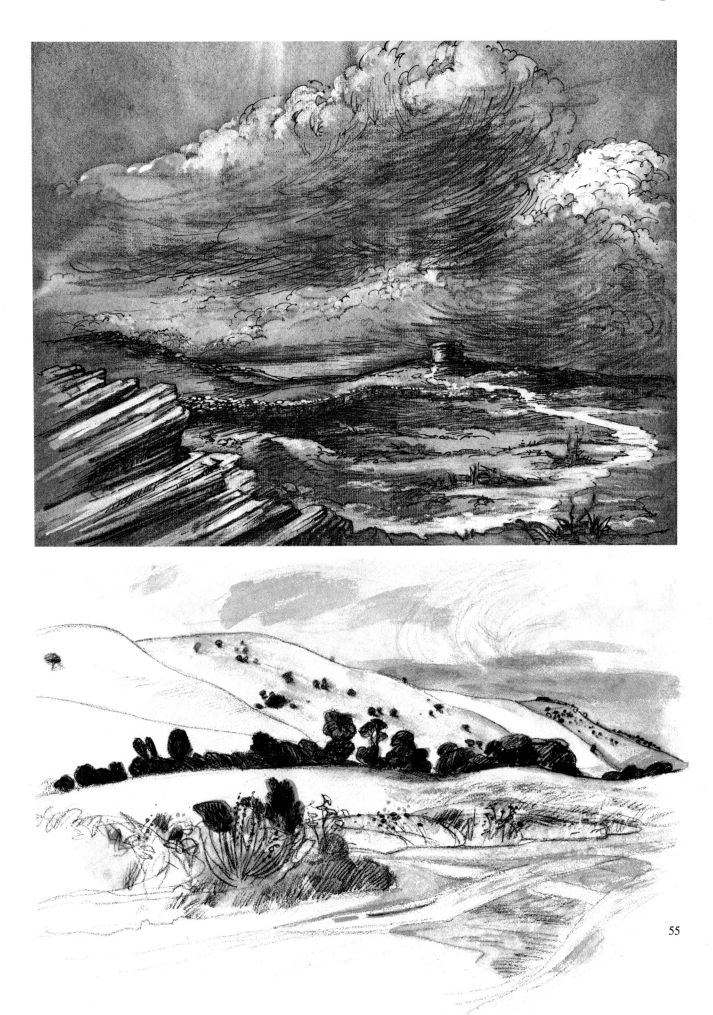

Buildings in landscape

It is hard to find, when we are drawing outdoors, a landscape that is devoid of any form of human artefact, be it houses, bridges, or even telegraph poles or pylons. One of the advantages an artist has over the camera is the ability to select; but buildings have their place in a landscape drawing — their hard angles and materials provide different textures in contrast to the organic material that surrounds them. A building can be (and often is) a focal point in landscape pictures: a church spire or long low barn, even a town or village in the distance — all will add to the interest of a drawing. Study the land and look at its form and texture. Learn to do this by spending as much time as you can drawing outside in all weathers. Such practice improves style, technique and accuracy; but it is your own interpretation that will make the difference between drawing a landscape and merely producing a photographic likeness.

Draw lightly, Norman Battershill advises, and resist the temptation to erase mistakes. If your drawing goes drastically wrong, start again. Before you throw away a bad drawing study it to analyse where you went wrong: we all learn as much from our mistakes as from our successes.

On these two pages buildings can be seen as either the focal point of a drawing, or integrated into it in such a way as to provide interest and contrasting texture.
Above: George Cayford's pen sketch of cottages in a lane was drawn in black ink with three kinds of nib — fine for distance and initial drawing-in, a medium nib for detail and middle distance, while the foreground and the tree were blocked-in with a calligraphic nib. This free style is dynamic yet intimate.
Page 57, above: a pencil study by Clifford Bayly of a farm house nestling amongst trees. The blacks of the extreme shadows and window panes provide a focus.
Below: the tone of this finished drawing in pencil, again by Bayly, shows how weight of line alone can move our eye through the flower heads to the buildings in the valley, and beyond to the distant hills. Practise this kind of control omitting shaded tone and using line only.

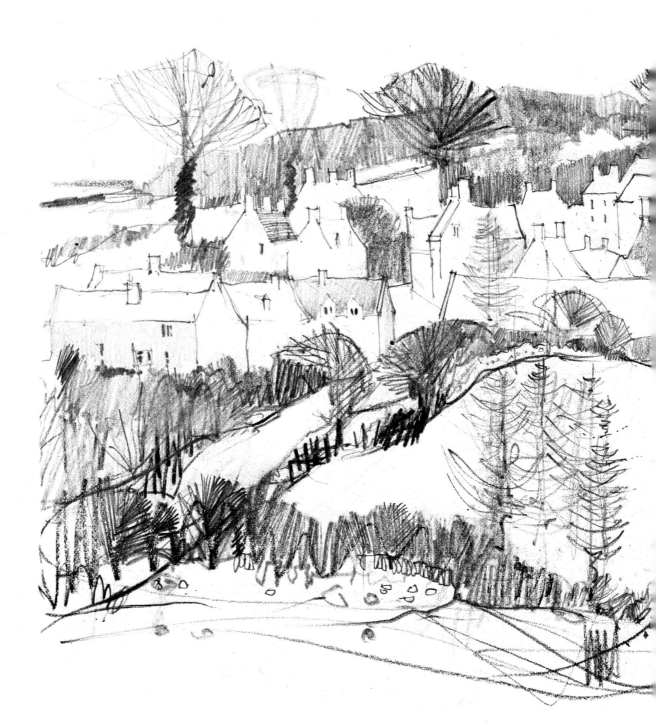

John Blockley's drawing of Cutsdean, a Cotswold village, in the depth of winter brings together in one study many of the points that have been illustrated earlier. Using soft pencil for the composition, he has employed also a hexagonal stick of graphite or plumbago (the same medium as in pencils) to add tone and emphasis where necessary. Notice how the whole picture is made up of distinct lines and marks — scribbles, dynamic and formal lines, and tones, are seemingly put down instinctively, yet each has its place in the composition.

The composition is based on a lozenge, the four sides of which run from the bottom left-hand corner to the tree, top centre, then down to the base of the church and

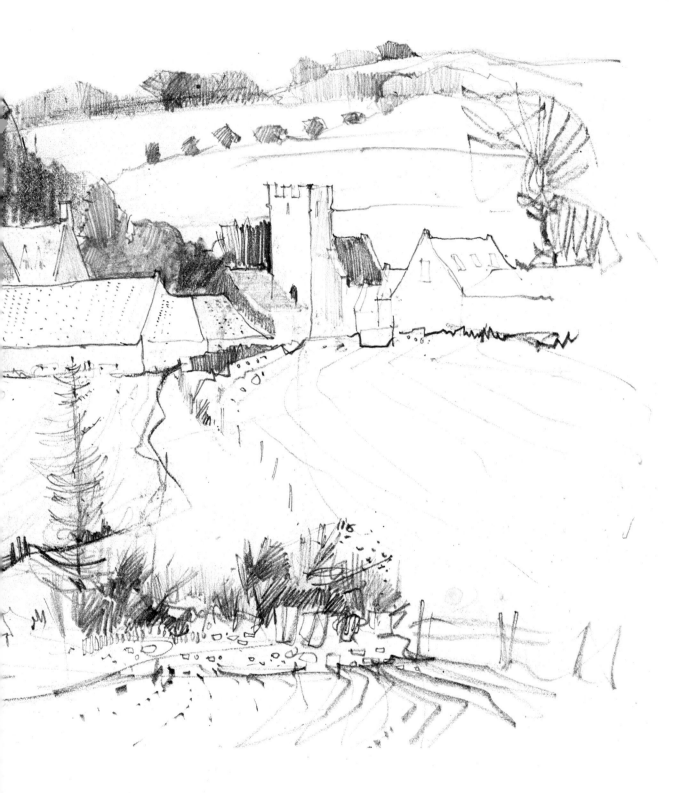

from there to the gate (bottom centre) and to the foreground. (Half-close your eyes and you will see the lozenge quite distinctly.) One's interest travels through the drawing, moving from line to blocks of tone, dark accents to light. Blockley uses the graphite stick on its side, producing varied lines and rhythms, at times hard and spiky, at others soft, in order to block in tone.

Other compositional lines and marks cross or radiate from the lozenge, the total effect being stark and wintry. Try to emulate some of the marks and lines he uses in your own compositions as an interweaving of continuums and punctuations.

Skies

How we are affected by the weather! And how it affects all we perceive. A cloudless, azure sky with the sun burning everything below it may be pleasant for the sunbather, but it is relatively uninteresting for the draughtsman. Yet as soon as clouds appear another dimension seems to enliven the landscape, throwing light and shade across it, highlighting one aspect one moment, casting it into shadow the next. John Constable wrote '. . . every gleam of sunlight is blighted to me in the art at least. Can it therefore be wondered that I paint continual storms?'

On these two pages Margaret Merritt offers sky sketches and drawings, some with attendant landscapes, others which are studies simply of the shapes and masses that form clouds. Study the sky as a subject in itself, as Constable did: or go further (as he also did) to relate the interplay of sky and land, sunshine through cloud, shadow of cloud upon field, woodland and hedgerow. So avoid the sun at its zenith — wait until its angle at morning or late afternoon is raking across nature: the clouds will then be thrown into relief and shadows dramatize the objects that rear up vertically from the landscape.

Margaret Merritt's sketches are done spontaneously and quickly in a variety of mediums. 'One of the problems,' she says, 'is that the blue sky is often darker than the clouds themselves. A wash or tonal block will establish the colour of the cloud at its outer edge very effectively.'

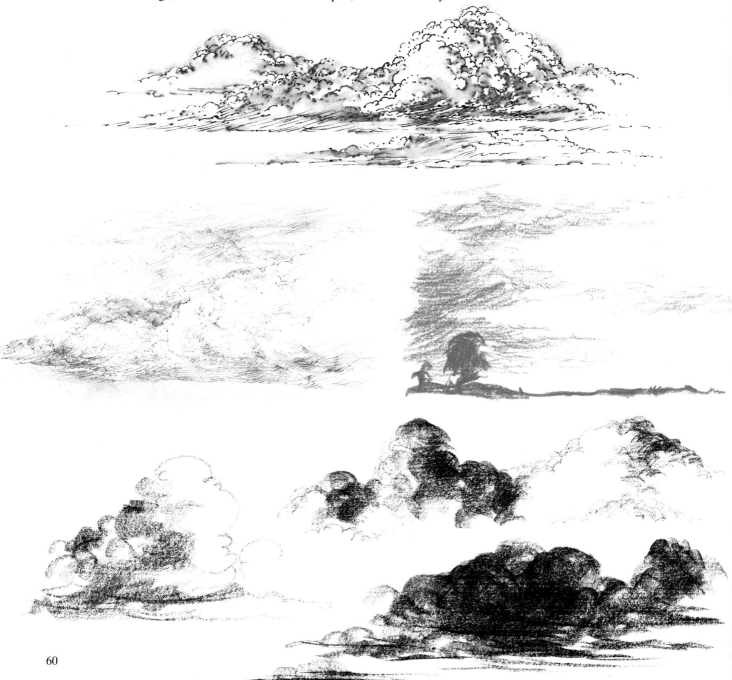

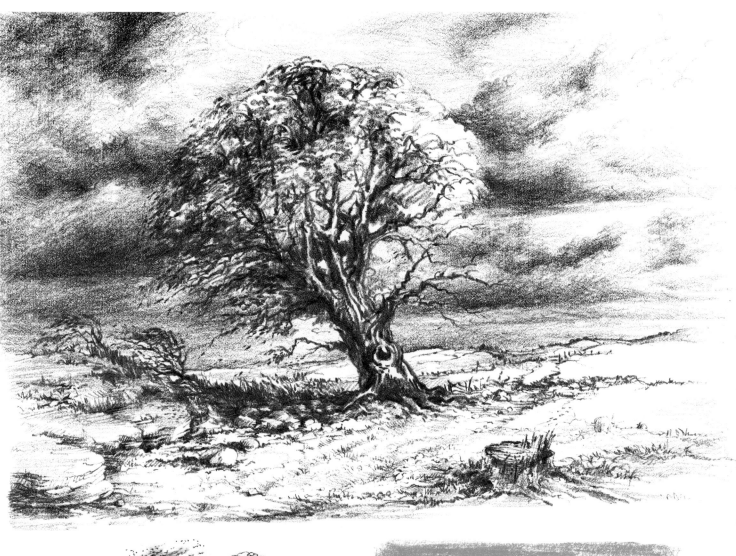

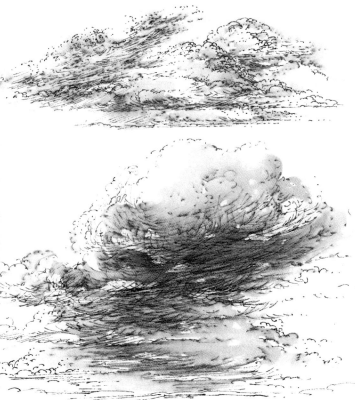

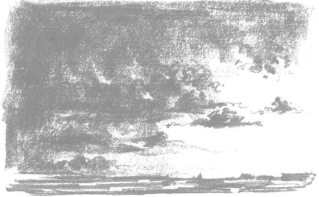

On the opposite page, and on this page, left and above, are various studies of cloud formations in light pencil and watercolour, fine water-soluble felt tip pen afterwards loosened with clear water to produce tone, and sepia and black conté. At the top of this page is a 6B pencil study of a storm over an old oak. Notice how the sun, breaking through cumulo-nimbus clouds, strikes the tree on the right-hand side.

Seascapes

By comparison with the sea, the land is relatively undisturbed by the wind. But a zephyr can disturb the sea's oily smoothness — stronger than that, it can raise wavelets, or immense breakers. Sun and moon also play their part in the creation of tides: no wonder the places where sea meets land exert such a fascination upon artists!

Take your sketch book when you visit the seaside. Subjects abound there. Our artists have already shown how sky and earth interact to provide endless variety. This is just as true with seascapes. In the tonal sketch below in pen and wash by Leslie Worth, a simple subject such as a breaking wave provides a dramatic drawing. But one has to watch hundreds of waves before one can capture such a subject; it is not just a particular wave but a synthesis. Sometimes we have to observe a seemingly endless repetition of events — in order to *analyse* such a picture before arriving at the moment to capture it. Make quick notes until you find that moment which satisfies you.

Rocks, sand, cliffs, houses, piers, boats — things man-made or natural — all have their place in seascape. The thumbnail sketches in sepia conté at the bottom of this page could be made into very detailed studies. Make plenty of such notes before settling down to draw your picture.

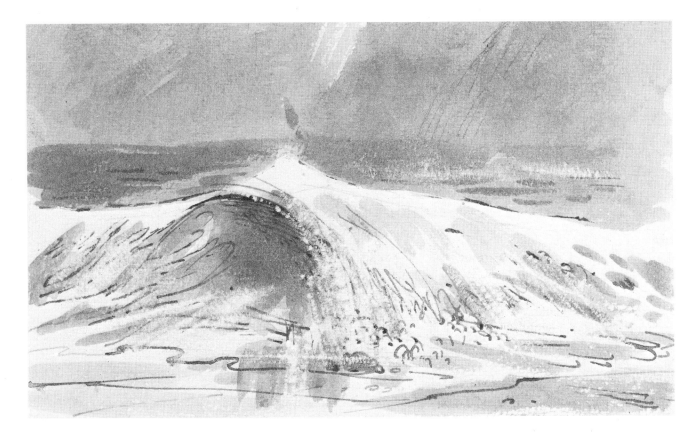

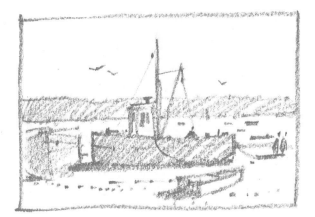

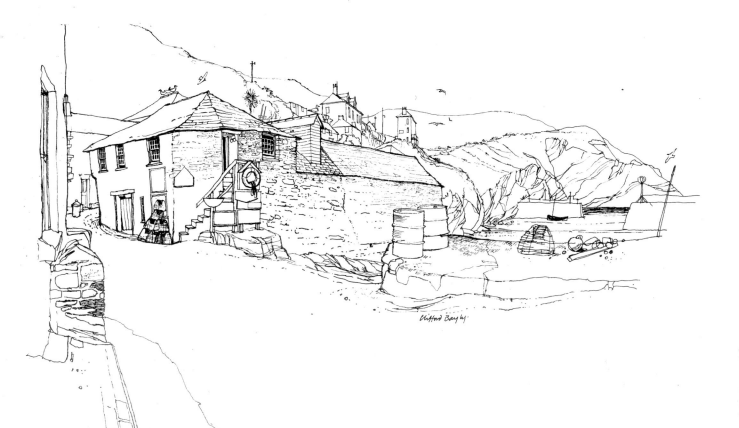

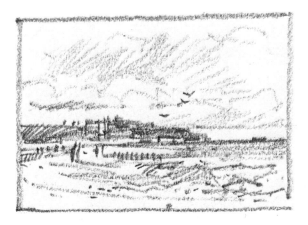

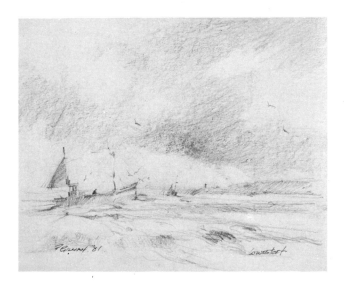

Top: *Clifford Bayly's meticulous line drawing, in fine pen and ink, of a road through a fishing village which leads (naturally) to the harbour, also leads our eye out across the mud to the open sea beyond the harbour wall.*

Middle right: *a drawing in pencil made on the foreshore of fishing boats entering harbour.*

Above, left: *a thumbnail sketch of a seaside resort made on rough surfaced paper with a carbon pencil.*
Right: *a study of waves breaking over slab-like rocks below a cliff. The drawings and sketches on these two pages only hint at the variety of subjects to be found at the seashore.*

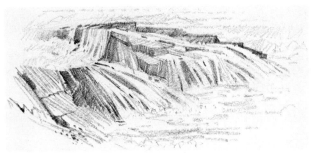

Landscape

On page 49, this section opens with a study by Margaret Merritt of a rocky and barren Minorcan landscape, relieved by the abandoned fort in the distance. This is drawn on grey Ingres paper in black ink and pen overlaid with pure brush strokes of undiluted and thinned washes of black ink, heightened with white watercolour paint.

 In contrast the section now closes with a tranquil pastoral of Kentish downland by Clifford Bayly. Although apparently serene it, too, is dominated by the weather, for rain is falling on the distant hills beyond the centre of the subject which itself has cloud shadows upon it. The foreground grasses and plants are blown by an uneasy wind which portends the rain shower moving into the picture.

Bayly has here used a rough-surfaced watercolour paper to draw upon in two strengths of pencil: one hard for the linear aspect, one soft for the blocks of tone that indicate the clumps of trees. Overall, and delicately, he has laid very diluted washes of Indian ink — sometimes wet and flowing, as in the background and sky; sometimes with a dryish brush as in the foreground, where he uses the grain of the paper to give a rough, grassy effect. Finally, with varying strengths of diluted ink, he dots in flowers and seed heads. Marks, lines, tones. Study again the sections on these aspects, and you will realise how Bayly has employed all of them.

Trees, plants and flowers

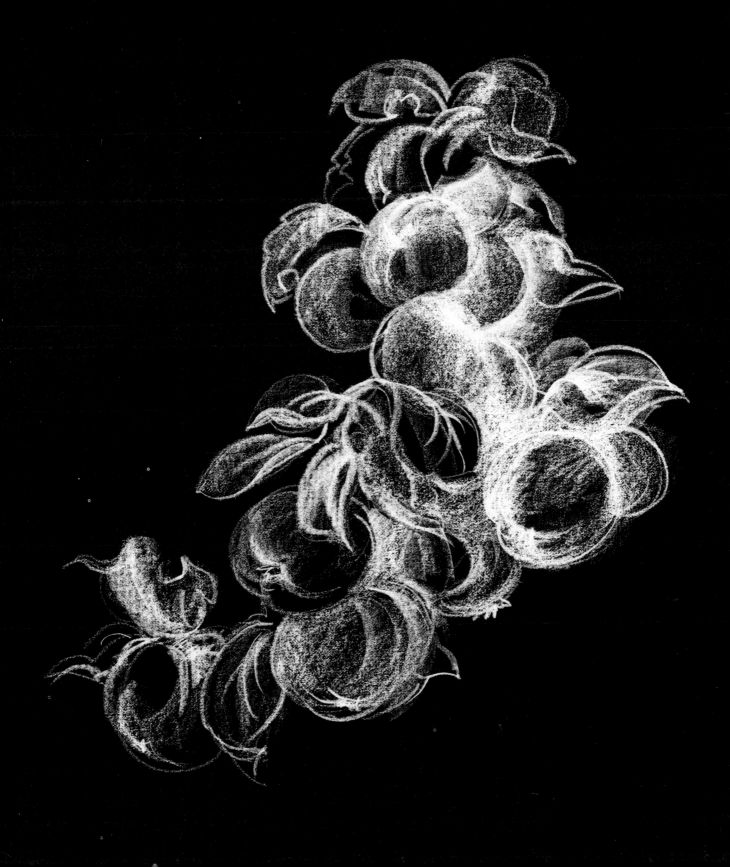

Trees, plants and flowers

Trees are an essential component of most landscapes and, as Margaret Merritt says, 'are worthy of special study. If we wish to give them identity within the landscape, then we must study their structure carefully. An ancient oak or a stand of Scots pine on a ridge could well provide a focal point for a landscape.'

A deciduous tree denuded of its leaves in wintertime is basically linear. Yet from its skeletal appearance one can see its basic anatomy: trunk, branches, twigs. From this skeleton we can learn much about it even without its clothing of leaves. If you are interested in botany, then from its bark, the way the branches spread out, the arrangement of its twigs, you can identify the species. From its rhythms, girth and height you can guess its age; from its broken branches and scars, its character. When drawing trees Margaret Merritt reminds herself of Ruskin's dictum: 'The history of a tree is within its branches'.

Conifers and deciduous trees in full leaf present artists with a complex challenge. Most find that it is easier to *paint* than to draw them. The way small and large masses of leaves throw themselves out from twig and branch in profusion can be bewildering. Margaret Merritt advises: 'first draw the tree in outline and then render the skeletal form of the main trunk and branches very lightly'. In the still-life section (*page 25*) we saw how quite complex shapes can be reduced to blocks, cones, cylinders and spheres; likewise she considers the shape of a tree in similar terms: an oak may be roughly spherical, a conifer conical. Once this is established, she observes how the light falls on this geometric simplification. She then seeks smaller geometric shapes within the total form. Through such simple intellectual analysis she arrives at constructional guidelines which provide her with an organized structure on which to base her interpretation.

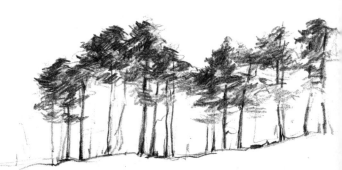

The two sepia conté drawings (above, and right) *illustrate Margaret Merritt's analysis. The drawing above, she says, 'is simply not thought through — it has a tree shape, which is all that can be said for it! The drawing on the right, though elementary, has structure and mass, and the basic forms are indicated by tonal contrasts of light and shade.' Notice too, her expressive use of marks. She uses a short stick of sepia conté; each mark she makes with it has shape, tone (lighter or harder application), and dynamic (the direction of the mark). All the marks in the drawing on the left are arbitrary.*

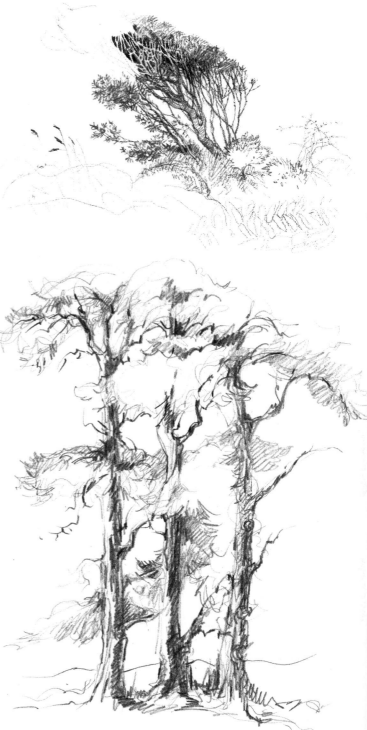

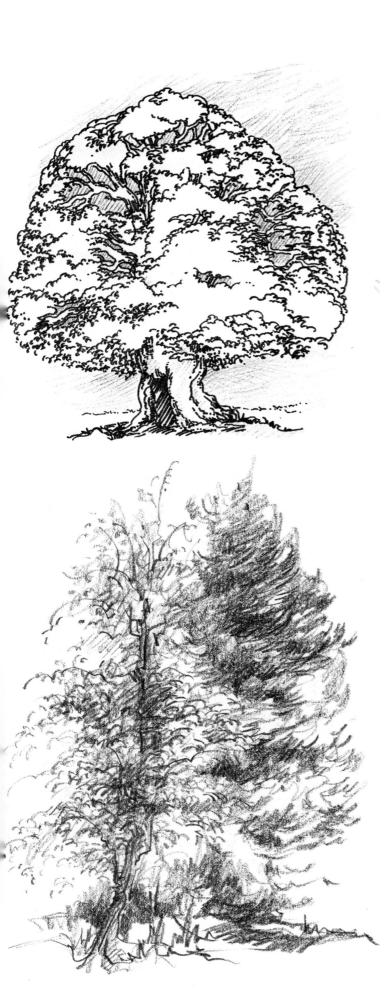

Top, left: *a stylised drawing of an oak tree in felt tip pen and soft pencil illustrates the importance of observing negative and positive space. Through shading in pencil the spaces seen through branches and leaves, the anatomy and bulk of the tree are shown, and lend it conviction and solidity.* Top, right: *Clifford Bayly shows dynamic use of tone in an unfinished drawing of a wind-blown gorse. See how the branches and twigs are composed: when silhouetted against the sky they are drawn in with dark pencil; when the mass of the bush is black he leaves the branches as white by blocking in around them.* Below, left: *contrasts in texture. A silver birch stands in front of a Sitka spruce (black crayon). The features and quality of the former demand different kinds of marks from the latter.* Above, right: *three Scots firs in 6B pencil. Notice how important are the negative spaces between trees and branches.*

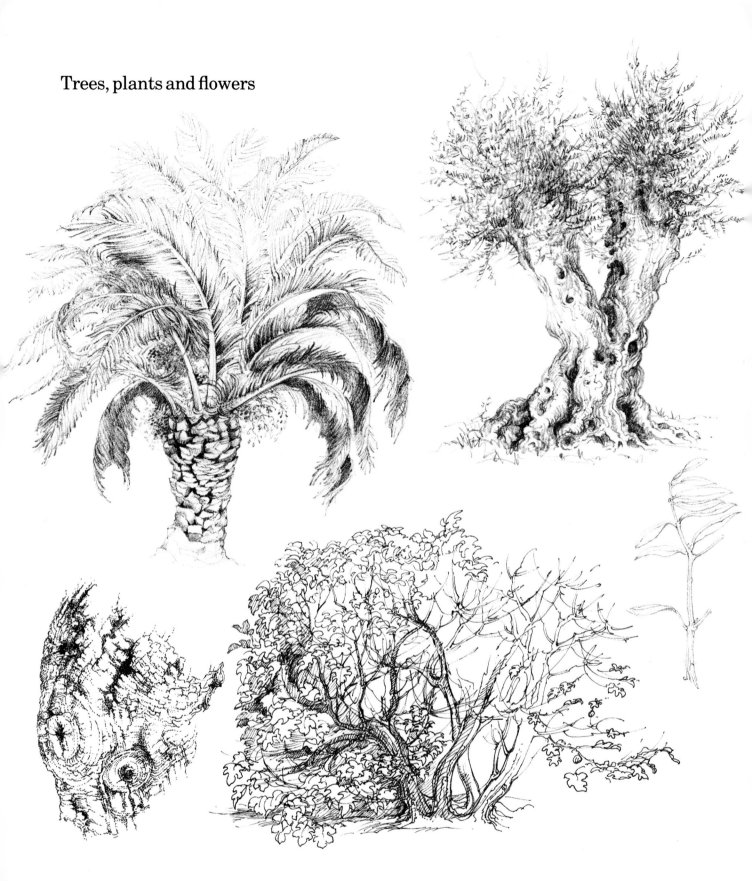

Trees

A page of trees by Margaret Merritt. The fig tree and the study of its bark and trunk (*bottom, right*) are in fine felt tip. The bark is meticulously observed, and provides a maximum of information about form and texture; the whole tree is drawn loosely and expressively. The wild olive (*top, right*) drawn in 4B pencil, although very old, still bears graceful twigs and leaves. The wild date palm (*top, left*) is a riot of textures with its exuberant fronds, bunches of fruit and calloused trunk from which the stumps of cut fronds protrude (6B pencil study). 'Always try to anchor your tree to the ground in your drawings,' Margaret Merritt writes, 'otherwise they tend to fly off the page.' (But she deliberately disregards her own maxim over the wild date palm!)

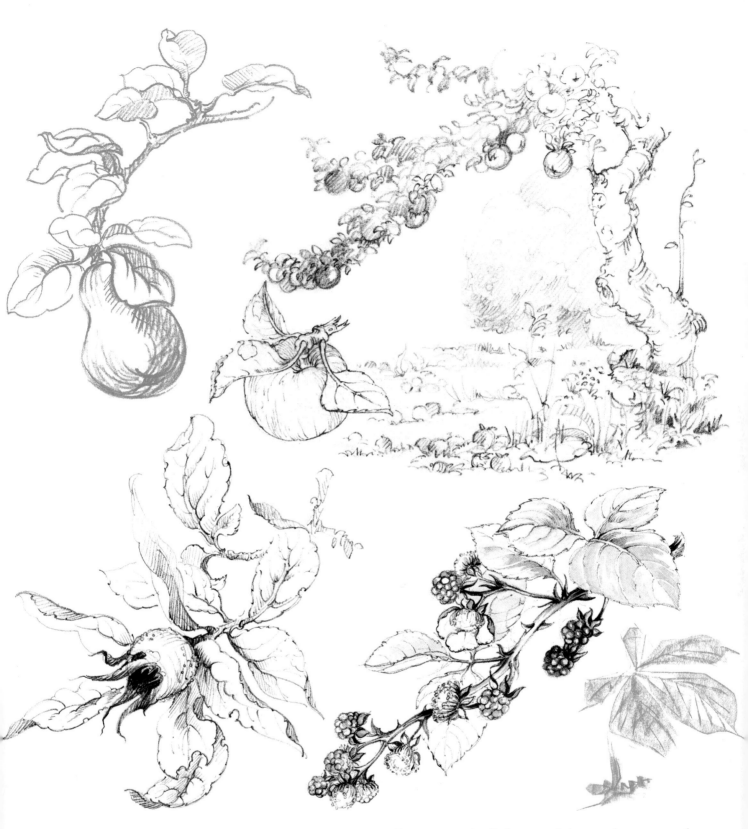

Twigs, leaves, fruit

If we want to understand yet more about trees and bushes, then take a close look at their twigs, foliage and, during summer and autumn, their fruit. Some twigs are long and graceful; others twist and turn, yet others are like arthritic fingers.

Leaves come in all shapes and sizes, and are arranged in groups, pairs or singly upon the twig. They are shiny, rough, furry. By the same token the variety of fruits is endless. Here, Margaret Merritt has drawn five studies of such plant material: horse chestnut leaves (sepia conté); bramble (pencil, Chinese ink washes and small touches of black ink with fine pen); old apple tree and fruit (soft pencil); quince (sepia conté crayon); medlar (6B pencil).

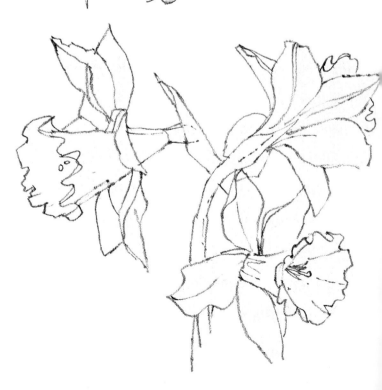

Flowers

A spread of flowers by Margaret Merritt and Norman Battershill. Remember, if you have difficulty in analysing the shapes of flowers, look for the underlying geometric forms. Think of the daisy family as being composed of discs and flattened spheres; daffodil trumpets as cones; bell-shaped flowers as a combination of spheres and cones; thistle heads as eggs that open out into cones . . .

Top, left: hybrid roses, drawn in 6B pencil. *Top, right*: geranium in a pot (soluble felt tip loosened with water — compare this looser study with the one on page 28). *Bottom, right*: outline drawing of daffodil heads in sharpened crayon. *Page 71, opposite*: rudbekia, marigold, delphinium, snapdragon (antirhinnum) and nicotinus, all drawn in 6B pencil. Try such studies using different mediums to portray the same subject, until you feel you have captured *your* interpretation. And if you are at all daunted, what better advice than Norman Battershill's: 'Why not begin with a single rose in a glass of water?'

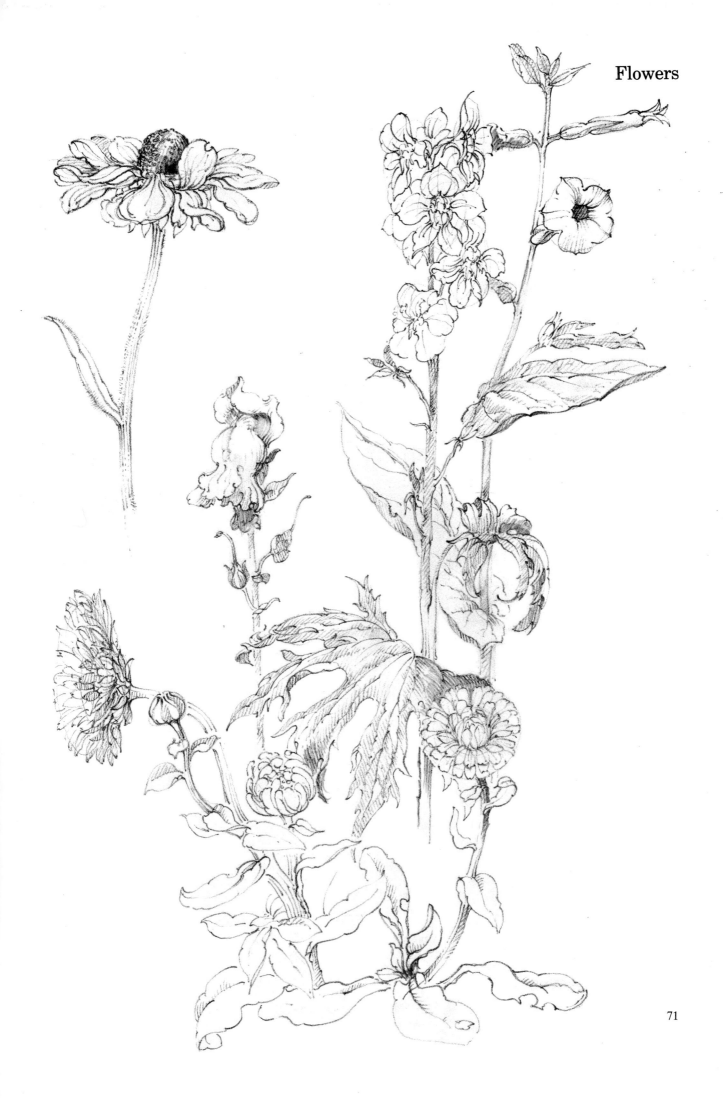

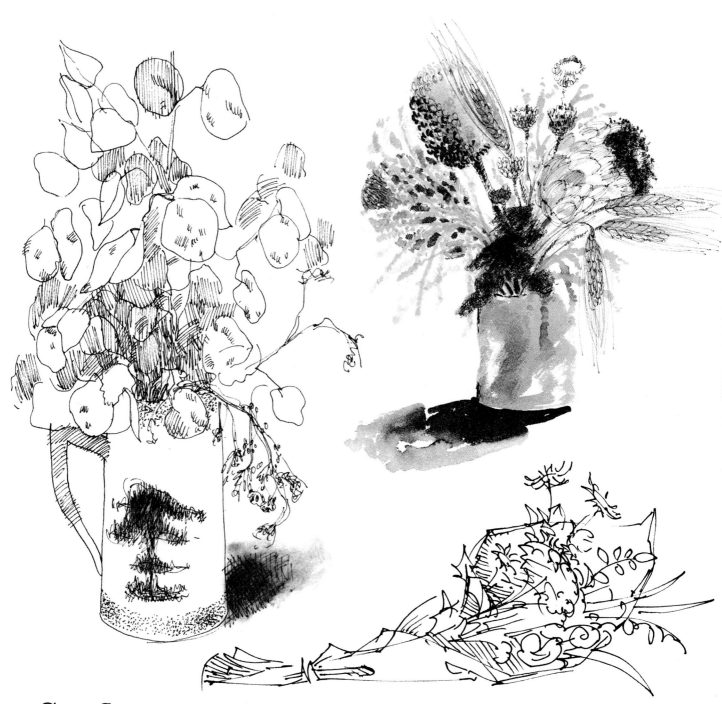

Cut flowers and dried material

Just as plants growing in their natural habitat, or in gardens or pots provide exciting material to draw, picked flowers arranged in vases or containers can also make good subjects. Bearing in mind Margaret Merritt's advice on how to look at plant shapes, pick from your garden (or, buy from a florist — mixed bunches are best) an assortment that pleases you. Do not forget to add foliage, or indeed to choose a vase or pot that will set them off to advantage. If you have a talent for flower arranging, then so much the better, for you will exercising your skills at composition; but remember you are looking essentially for shapes, tones and linear effects. Once you have drawn several such groups try to incorporate flowers into a still life, or make them a focal point of an interior drawing.

Dried flowers and leaves, grasses and seed heads, all make splendid subjects on which to practise your drawing, and they have the advantage of being semi-permanent. Here Clifford Bayly draws in line, with the merest touches of tone, dried honesty in a kitchen jug. George Cayford approaches his loosely described drawing of mixed seed heads by applying loose washes of Chinese ink with a brush and then going over the whole with a fine dip pen in black ink. Gauge for yourself the different degrees of information and expression between the two drawings. Margaret Merritt's pen sketch of a wrapped bunch of flowers completes the section.

On page 65, the section opening shows a white chalk drawing on black paper of an apple branch by Margaret Merritt.

Buildings and towns

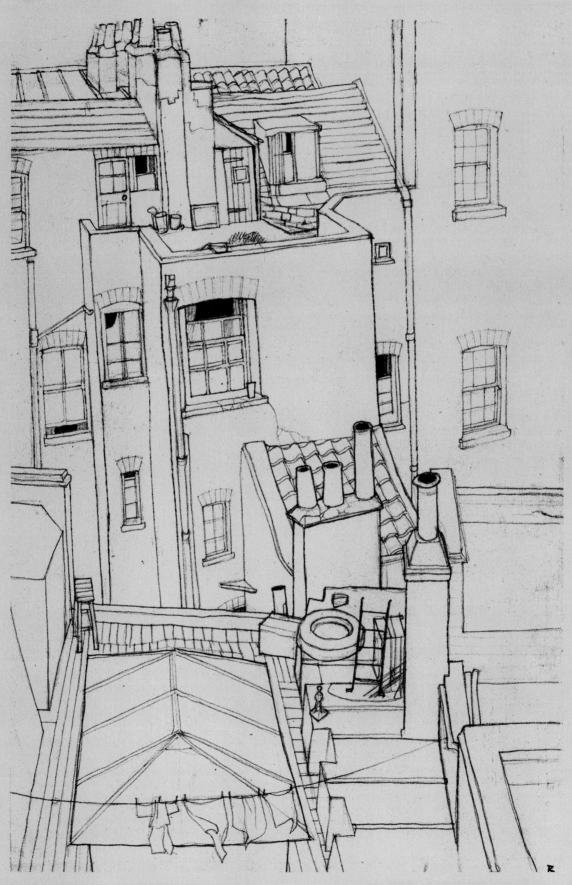

Buildings and towns

Most of the buildings that surround us are outsize replicas of the materials of which they are made — bricks, stones, slabs of poured or cast concrete — and, as such, they are basically rectangular blocks.

In previous pages our artists have touched upon the subject of perspective. Perspective — the very word frightens off many an aspirant of better drawing. If you are, don't be! Perspective is a technique, not a skill, and it can be earned quite easily, at least enough to aid your drawing skills to the extent of mastering all but the most complex problems of recession.

Although we *know* railway lines are parallel, if we stand in the centre of the track and observe a straight section to the horizon the lines appear to converge to a point. Similarly, the outlines of straight buildings taper off — continue those lines to the horizon and you will find the same effect as with the railway lines.

The point at which they converge on the horizon — which, in perspective, is the eye line — is called the vanishing point. On the top right of this page is a diagrammatic illustration of single vanishing-point perspective; and the straightforward street scene below it, with an overlay in sepia line, illustrates this. Once we have grasped this simple rule we realise that, the further off from one's eye objects or parts of an object are, they appear to recede. Each and every object, even objects of the same size, obey this observational rule.

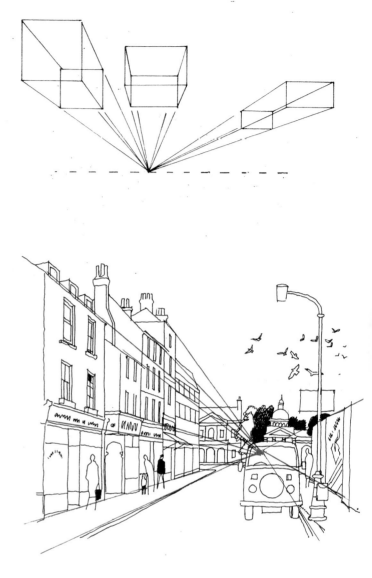

Below: *felt-tip pen sketch by Richard Bolton*

Opposite, page 75, top: *a pencil drawing by Richard Bolton, with perspective lines drawn in directly on the drawing. Notice that the horizon line is at the eye-level of the figures; the perspective of the street radiates below and outwards from the vanishing point. Remember your own height, whether standing or sitting, high up or low, when viewing your subject — look straight ahead, and imagine the perspective lines radiating from the vanishing point. Clifford Bayly's pencil drawing (below it) observes these rules: his viewing line is opposite the street corner.*

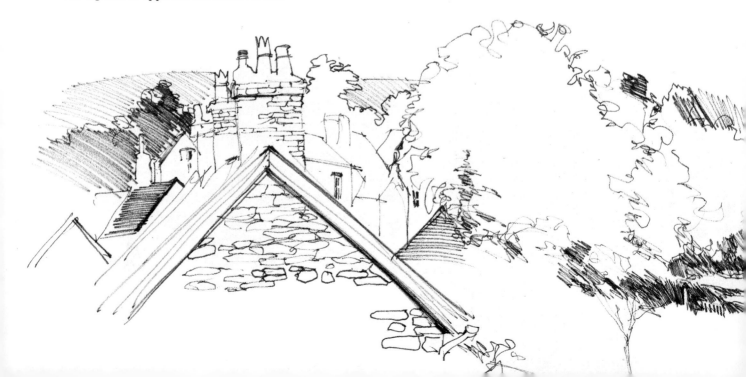

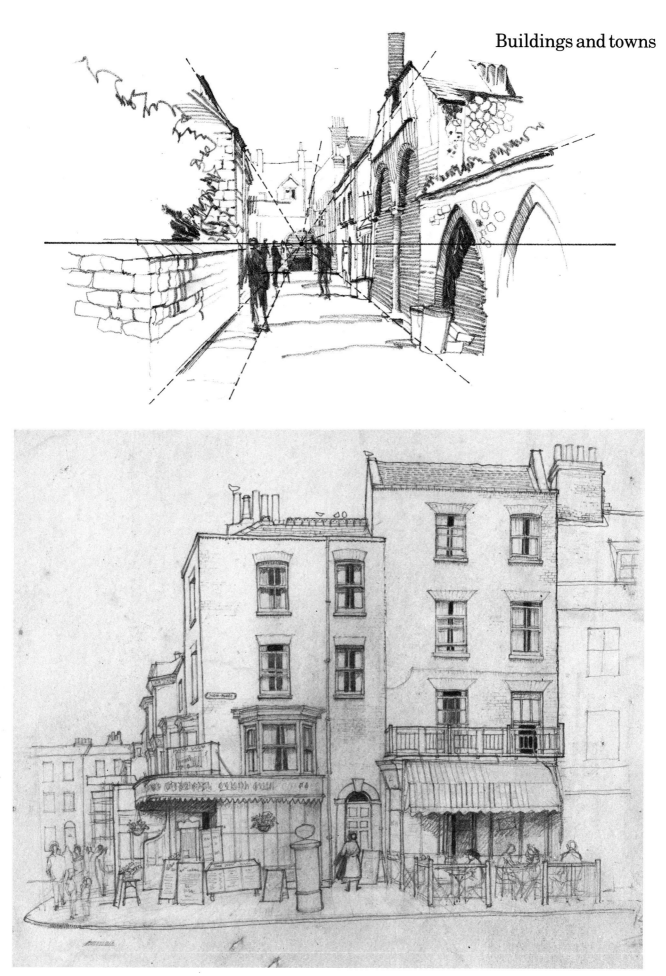

Buildings and towns

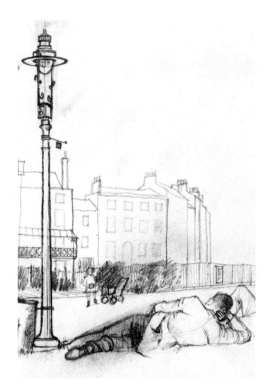

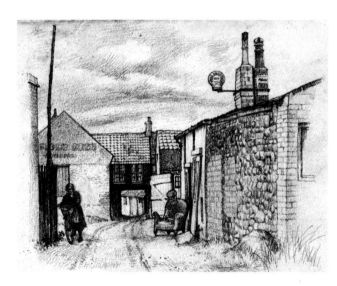

There are innumerable ways of interpreting buildings through drawing, whatever mediums you choose. *Top, right*: Clifford Bayly employs a peep-show technique. By using negative space (sheets on clothes line) he creates a townscape by drawing the background in dark tones of soft pencil on watercolour paper. *Top, left:* he shows his interest in street furniture — lamps, pillar boxes, litterbins, posters etc. Such subjects as these — and people, of course — will help to enliven your own pictures.

Two contrasting techniques show how to select from a subject what are its salient features. *Above*: the purely linear aspect creates a keenly observed study of rooftops — any further detail or added tone would destroy the elegance (*see also page 72*). *Above left*: the textural quality dominates. Brick, stone, wood, tiles, are all given their full value by careful use of tones. (Drawings by Clifford Bayly).

Left: midnight in the city. A sepia conté pencil sketch making the silhouette of buildings against sky the main focal interest. Note the dynamic dark-to-light drawing of the branches in the foreground. *Below*: a loosely handled sketch of an industrial plant, by Richard Bolton. Over a pencil outline, washes and lines of monochromatic watercolour build up the subject. The industrial scene provides plenty of fascinating subject-matter for the perceptive artist. *Bottom*: an almost panoramic view of houses in a village joined by a bridge over a river. In felt pen Richard Bolton uses blocks of tone to suggest the trees and grass, putting in the detail in the houses where he wishes to concentrate our interest.

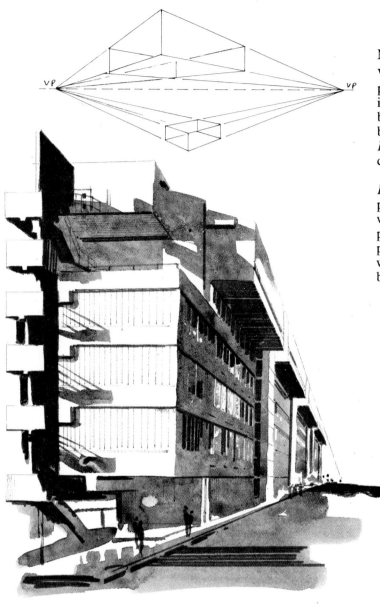

Modern Buildings

When we view buildings obliquely, two vanishing points appear on our horizon line. This is demonstrated in modern buildings where they are composed often of box-like shapes or assemblages of large and small boxes. The diagram on the left (*above*) illustrates this. *Below*: the drawing of a high-rise hotel block in sepia conté crayon demonstrates this technique.

Left and bottom: drawings by Richard Bolton in pencil and ink washes, and HB and 6B pencil. 'If you want to draw with a ruler, then do so, so long as your perspective is accurate,' he advises. 'If the end-result pleases you, then that is the main thing. But try, whenever possible, to draw freehand: that way you will build up your confidence.'

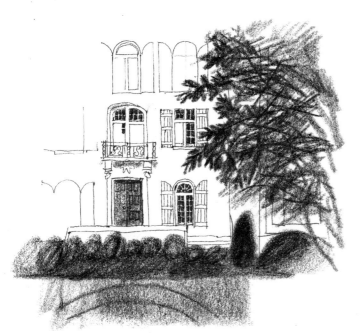

Going on holiday

The features which we probably notice the most when we go on holiday abroad, are the buildings we encounter when we wander through the towns and villages of the countries we visit; so be sure to take your sketch pad and drawing materials along with you.

Clifford Bayly's three drawings show holiday sketches. *Left, top*: fine pen and wax crayon captures enough detail to give an impression of a splendid continental house. *Middle left*: a sketch in fine pen on Ingres paper of an old house built over a culvert. *Below, right*: a pen study of a French barn — just a few of the irregular stones from which it is built are detailed above the gloom behind the half-open door, while the hens in the foreground complete the picture in our mind's eye.
Bottom: a drawing in pencil by Richard Bolton of a Portuguese town. Since he is left-handed, his shading moves from top left to bottom right.

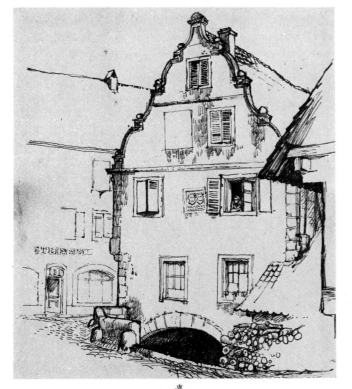

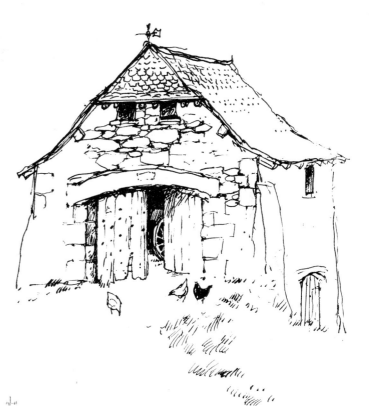

79

Buildings and towns

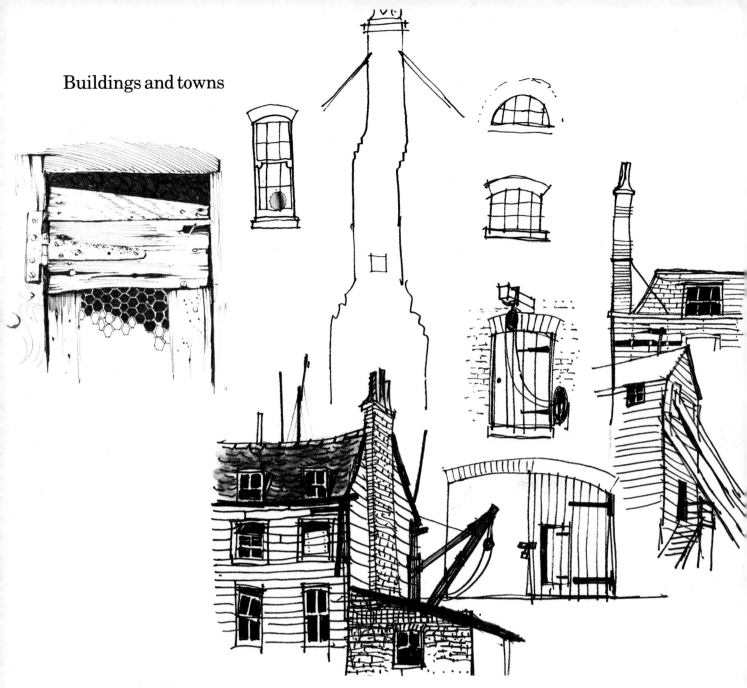

Detail

All subjects for drawing and painting are made up of a variety of objects and pieces, each of which can be a study in itself. A building has its components; windows, doors, chimneys etc. On this page Clifford Bayly and Richard Bolton draw details of buildings that have taken their interest.

Top, left: Bolton draws in fine pen and black ink a rusty hinge half-supporting a ramshackle chicken shed — an apparently unprepossessing subject which he has turned into a drawing full of closely observed textures. 'There's a wealth of texture, interesting rhythms and shapes to be found in derelict buildings and demolition sites,' he says. Another study by him, in soft pencil, of an old barn, is shown at bottom left. *Above*: a page of notes in felt tip pen by Clifford Bayly. One feels he has walked around the whole area of these historic wharves, capturing the essential textures of clapboard, tiles, brick and windows before the demolition men move in. Notice how he has loosened the soluble felt tip drawing with a clear water wash to give tone to the tiles.

Using colour

For the introductory page to this section (page 81) George Cayford had only to look out of his window in Hampstead, when the net curtains were being gently stirred by the afternoon breeze, to see his picture. What could be simpler — yet more effective for his purpose — than this ordinary view which he sees most days, yet which is rendered mysterious and revelatory by the wind? Such glimpses come to every artist who prowls about his world, examining the commonplace for subjects which the 'seeing eye' can transform into pictures. Cayford here breaks most of the rules of composition: his main point of interest is central. Strong horizontals divide the page evenly, yet his treatment encourages our interest. By drawing the whole picture in wax pastel, then crispening the focal point — the scene *through* the net curtains — with coloured line and blobs of ink he redeems the seeming banality of the composition. This is one of the beauties of using different mediums in one drawing. Cayford uses pastel to create the 'out-of-focus' surround which intensifies the detail of his flower box and the house opposite.

Brief sketches such as that below can easily be transformed by colour into more descriptive subjects, which tell us not only about line and composition, but suggest the colour (and hence increase the vocabulary of the information we portray).

Spring flowers

Norman Battershill uses a carbon pencil and coloured felt tip pens to create this intimate yet dashing composition — a fistful of spring flowers gathered from garden and hedgerow, and scattered on a white sheet of drawing paper. He says: 'First I draw in the general shapes with the carbon pencil and then follow these lines with coloured pens. Then I start building up the flower arrangement but at this stage I am concerned with the outlines, not with the smaller details of each flower. An

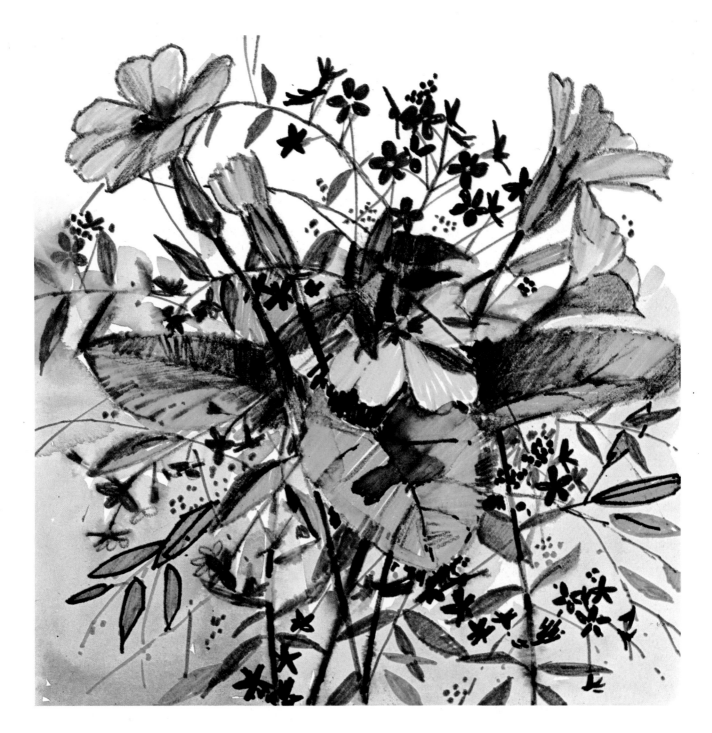

arrangement is beginning to form now, and as I draw I am aware of creating patterns, particularly of flower stems and petals, and bringing them into a balanced composition. You need a lot of patience and care when drawing the details of flowers with inks, as there is no chance of rubbing out if you make a mistake! For this reason important details are left until last. Having drawn in more with the pen, a wash of clean water over the drawing loosens the ink and spreads it into interesting blurs. I then draw into these again to finish off the sketch. In this drawing shading has been kept to a minimum but there is still an effect of light and shadow.'

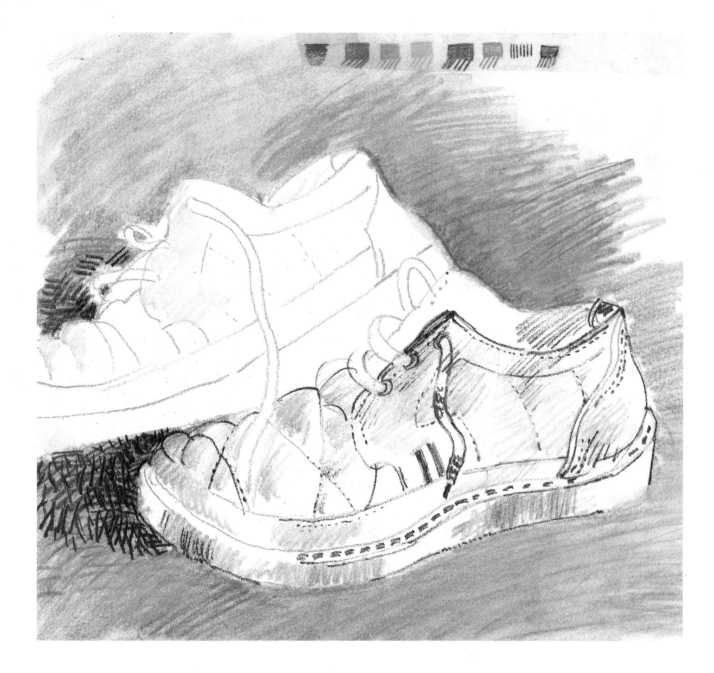

Jogging shoes

'When I come home from archery,' says George Cayford, 'I usually just stack away my gear and throw my shoes into a corner for I'm completely worn out!' These casually discarded shoes then caught his attention as a subject for a drawing. The soft, quilted uppers with their shiny texture suggested to him that he draw them in pastel crayon, the simplicity of the subject that he limit himself to a handful of colours, which he has indicated at the top of the half-way stage drawing on page 84. The way he has composed the shoes on the paper is interesting — apart from the shoe-lace dangling vertically almost all the lines converge towards the toe of the far shoe — which he has deliberately cut off. Because we are sophisticated in looking at pictures, we can recognise half or even a small piece of an object in a picture without seeing the rest — in fact, the piece that we are given heightens our intellectual interest in the picture, so long as that part gives us sufficient clues to fill in the rest with our imagination. In Cayford's picture, it reinforces the casual, unposed aspect of his jogging shoes — they *look* as though they have just been chucked in a corner.

Notice how he builds up his picture. After the

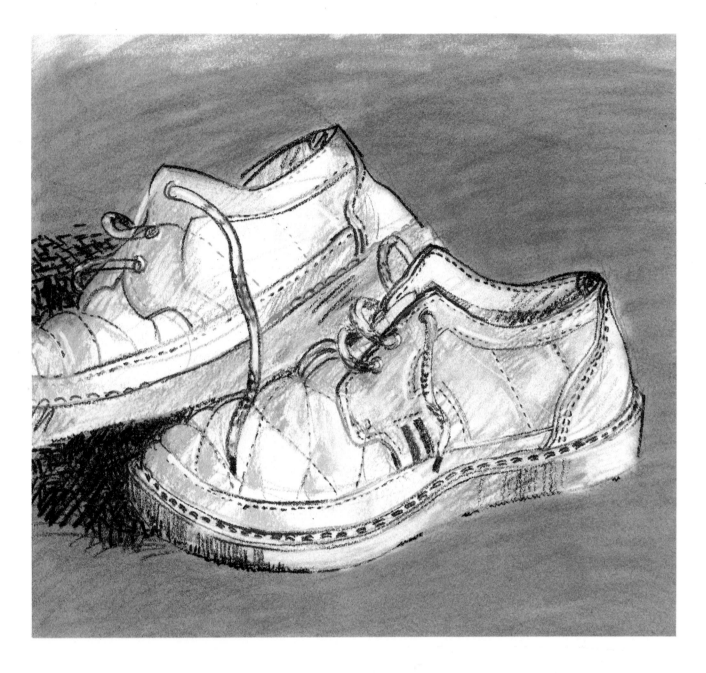

considerations of composition he draws the shoes in
outline in pale blue, emphasising that this is a coloured
drawing, not a drawing coloured afterwards. Colour
hues and tones are blocked in with careful but free
shading in the other colours he employs. By contrast he
colours the background in a warm, overall sepia tone
which is enlivened by touches of green. The white paper
does the work of the highlights. Detail is added when the
general effect is achieved.

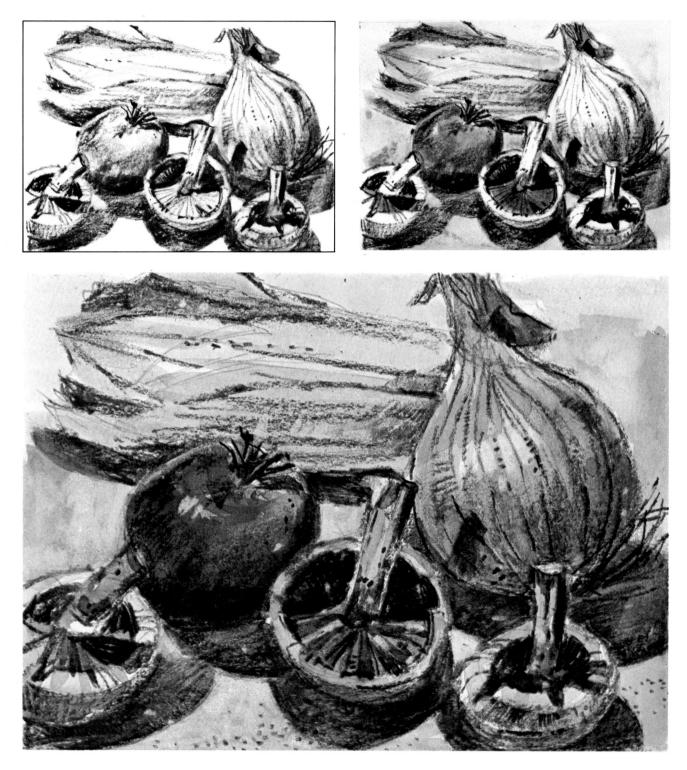

Vegetables

In this demonstration Norman Battershill uses almost as many mediums as there are different vegetables in his drawing — carbon pencil, charcoal, graphite pencil, watercolour and soft pastel on grained drawing paper. 'I draw in the outlines with pencil, then establish the tones with charcoal,' he writes. 'I add the darkest tones in carbon pencil — when I have established the main contrasts I spray the drawing with fixative. Washes of watercolour are then added — finally I add touches of silver soft pastel to bring out the highlights.'

Using colour

From the kitchen table to the High Street. The two drawings on this page illustrate the diversity which one can find in city or town. The sketch on the left would almost be cartoon-like were it not for the naturalistic attitudes of the two groups of women in conversation, youngsters walking away in the background. Apparently sketchy, this drawing conveys atmosphere rather than detail — yet in a few lines and colour washes a simple conversation piece is built up, related by the two scruffy boys.

The sketch below captures in brush and watercolour alone the cyclist riding down the main street after a shower of rain. All the artist has done is to draw a few pencil lines to guide his brush and, with judicious use of masking fluid beforehand, he picks out the detail of buildings so that they will show white. The rough surface of the watercolour paper adds texture, the edges of the watercolour splashes being blurred with added clear water to soften them.

Cat on the mat

George Cayford's tortoiseshell cat lay on the striped rug beneath his workbench and looked up at him playfully. Cayford quickly drew in the cat and the rug in soft pencil to catch the composition he wanted; then, using broad-wedged felt layout markers he established, in grey and brown and with short broad strokes, the effect of the cat's fur. It was important to catch the cat's position before it moved, so he then went over these marks with a black marker to establish its form and the shadows. He then drew in the cat's details with black

ink and a fine nib over the top of the marker strokes (which dry immediately), following up with white ink and fine nib. In this way the cat's shape and fur texture are described. Finally, he blocked in the bright stripes of the rug with coloured layout markers. Brown stripes are achieved with green over red. After painting in the tassels, he went over these with white ink and fine pen. In the panel down the left of the half-way stage demonstration, you can see the effect and colours of the markers, pens and inks that he used.

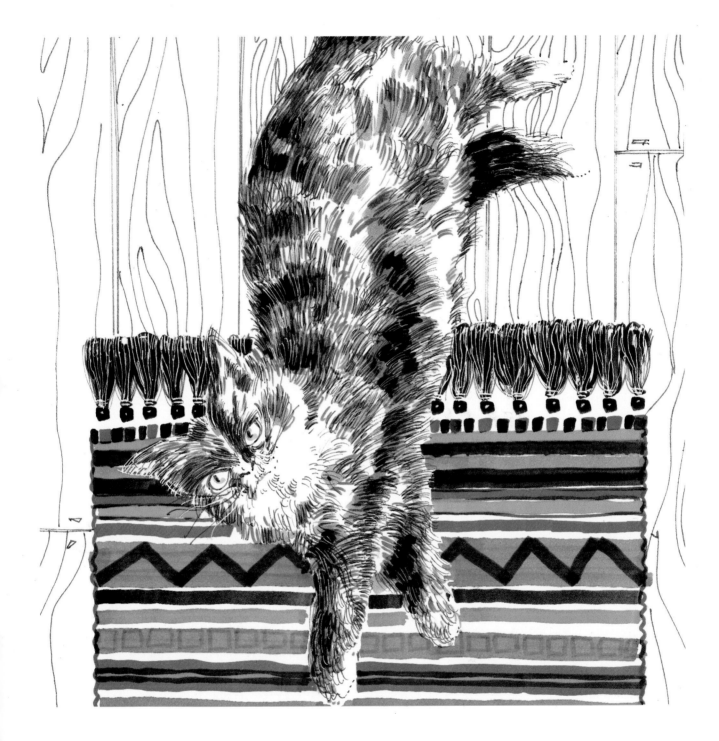

Again Cayford cuts his main subject, the cat, off at the top giving the whole air of immediacy and playfulness. One wonders whether the tail was constantly twitching! Such studies as this are fun to do and can be very effective. Try to use as few colours as possible, and work boldly.

Stalking the subject

Why a pear in a glass jar? Or indeed a pair of shoes, as previously (*pages 84–5*)? Artists have a knack of seeing the extraordinary in the commonplace. In the next four pages Cayford 'stalks' his subject until he has arrived at his exact concept. You will see in the preliminary drawings how he works the jar with the pear trapped inside it all over a flat surface, studying how the light falls on the jar and the pear. Notice too how he makes drawings of detail, balancing these rough compositional notes in the square format until he feels he has the composition he wants which will express best his mind's eye's concept of his picture. Some drawings are outlines, some taken to the point of almost being finished (to try out the particular technique of *how* he wished to represent his subject). Cayford says: 'Before I started to draw I spent some time in trying to decide what it was about the subject that excited me, why I felt the need to draw or make a picture of the subject — what is my *concept* in the case of the still life "Pear in glass bottle" (for you there could be different criteria). The reason I wanted to make a picture of the subject was the effect of intensifying the fleshiness of the pear being trapped and enclosed by the mechanical perfection of the glass.

'In starting to make this picture I try out many roughs for composition, materials and lighting effects in an effort to realize the original concept. The roughs are just a selection of the many I needed to do. This is a very important part of picture-making; however well drawn, the picture will "fail" to interest and satisfy you unless the composition is exciting and enhances your original concept.

'In this case I chose to draw the pear with a cross-hatch technique, using four very thin coloured crayons and a 7B graphite pencil on 'not' surface cartridge (a semi-smooth paper), as I thought the rough texture of a heavy textured paper would be too pronounced and not help the smooth effect I wanted in drawing the glass jar.

'I used a ruler or straight edge of paper as a mask or stencil to help give a sharp clear edge to edges of tonal areas in the drawing of the glass jar. I work the main components together, always trying to realize the original concept. I stop the moment I feel I have achieved this, for an overworked picture is almost always lacking in visual sparkle and interest.'

On the top part of page 91 Cayford has illustrated the main techniques he has used: softening the dark tones of the glass jar with putty rubber, masking off areas with a piece of blank paper; cross-hatching with coloured pencils to obtain the fleshiness of the pear. See how his strokes follow the pear's contours, blending together to produce a smooth effect.

Using colour

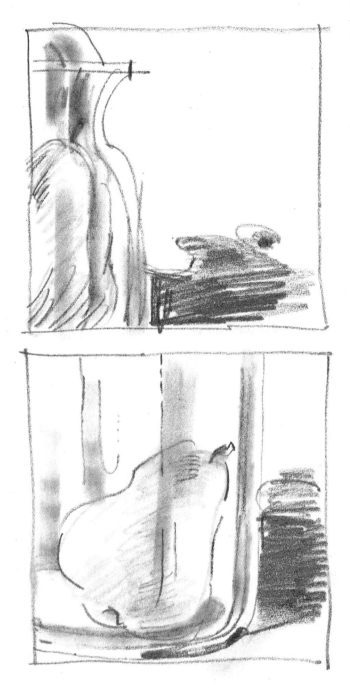

Four more compositional notes for the finished drawing opposite. As in the previous preliminary studies Cayford keeps the sketches for the composition deliberately loose. Notice how he blocks in tones very roughly: composition is not only about the linear aspect, but also the tonal aspect. Cayford's tones in these visual jottings are not necessarily accurate, yet they describe the compositional elements sufficiently for him to analyse, compare and ultimately choose the final composition. In the bottom right-hand sketch he is beginning to catch the relationship of the pear to the glass it is seen through, although he eventually selects the top right-hand one. In each of the sketches the composition is 'right'; the one he has finally chosen allows him to explore the textural qualities of both pear and glass more thoroughly.

Pear and glass

Composition, acute observation and the appropriate technique have been combined to give a crystalline, almost super-realist quality to the finished drawing. Cayford's preliminary sketchwork and analysis of his subject has enabled him to arrive at the result he intended. 'If you feel that a ruler will help,' he says, 'then use one, but only if the concept demands it. I used a ruler in the drawing above, as well as straight edges of paper for masking along the shaded areas. There is sufficient freehand drawing in the rounded shapes and reflections to give the subject variety and achieve the textures I set out to capture.'

Using colour

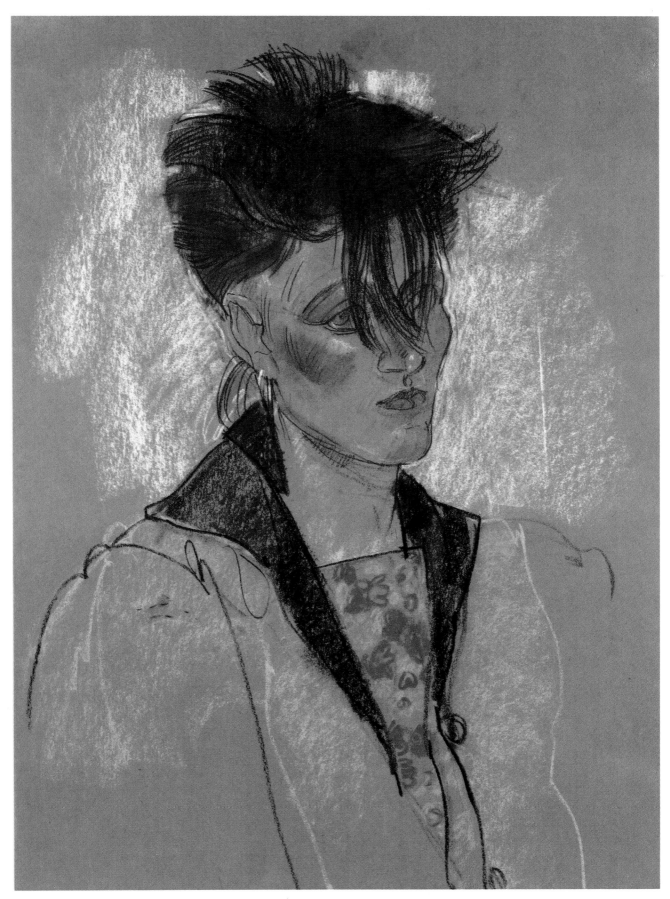

Drawing portraits in pastels and conté

Cayford finds some of his most interesting subjects for portrayal amongst theatre people and the decorative young. His pastel drawing (*page 94*) is done on ordinary brown sugar paper. Despite her flamboyant appearance and strong colour make-up, there is an air of feminine wistfulness about his model. Drawing in the main outlines and features in fine black pastel line, he then applies the colour carefully over the face, being most expressive with her clothing. White pastel about the head and shoulders dramatises the portrait.

On the right, he draws (again on sugar paper) a nude in black, sepia and white conté, traditional drawing medium of the old masters. In portraying the young man's head he draws expressively and entirely in colour pastel.

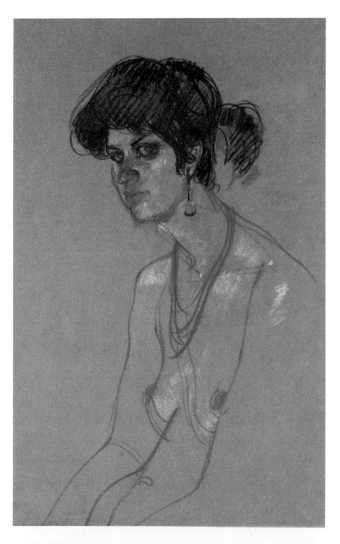

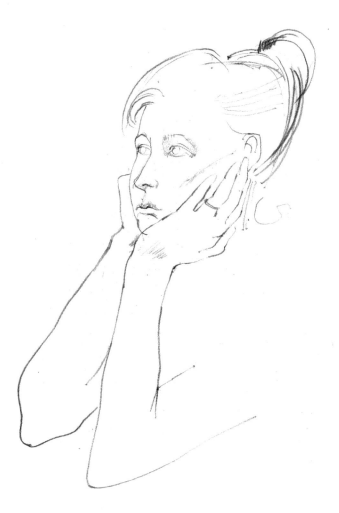

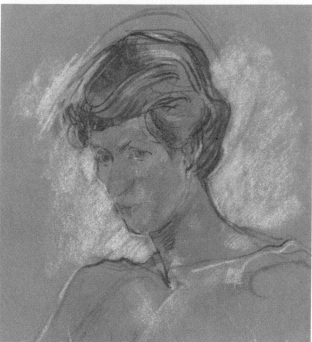

Jack Yates' pencil drawing of a young woman is carefully observed and drawn — such studies could well form the basis for moving into drawing in colour.

Using colour

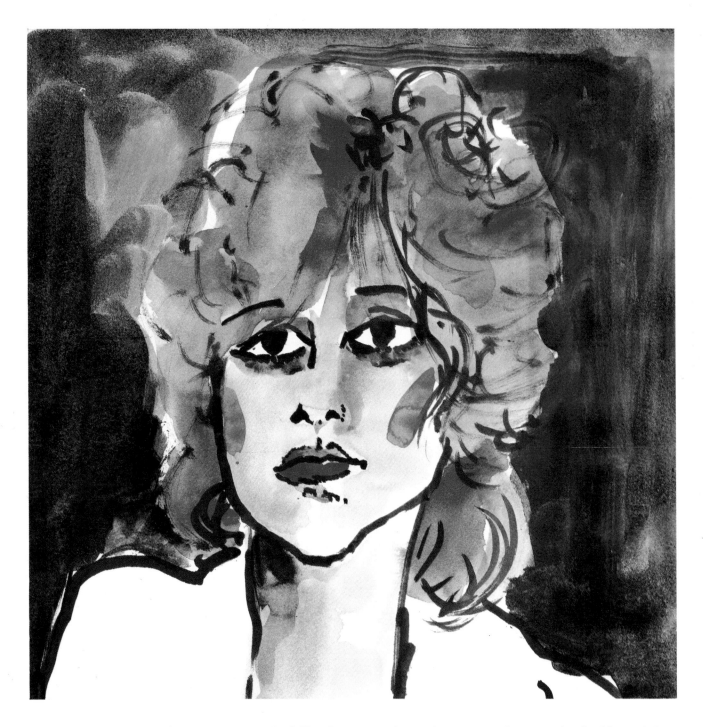

In complete contrast to the previous pages, Jack Yates' portrayal of a modern young woman with dyed hair and flamboyant make-up is drawn directly with a brush and waterproof black ink. It is not so much a physical portrait of her but an expression of her personality — vibrant, even arrogant. He has drawn the essential outlines and features with bold lines and strokes of his brush, thinning his ink with water only where necessary for the background and on the shadow of the neck. When the ink is dry, he quickly adds bold watercolour washes — the orange make-up on the cheekbones is just indicated with broad strokes of colour. But look how cleverly he adds the shadow of the nose in cool greens — echoed in the cheek on the left, which gives the colour balance to his vivid sketch. It was completed in less than half-an-hour. To achieve such spontaneity of effect you need a large sheet of paper — Yates' sketch was done on a cartridge layout pad 20" × 16" where his hand and brush could move broadly, rapidly, and with complete expressive freedom.

Figures, portraits and animals

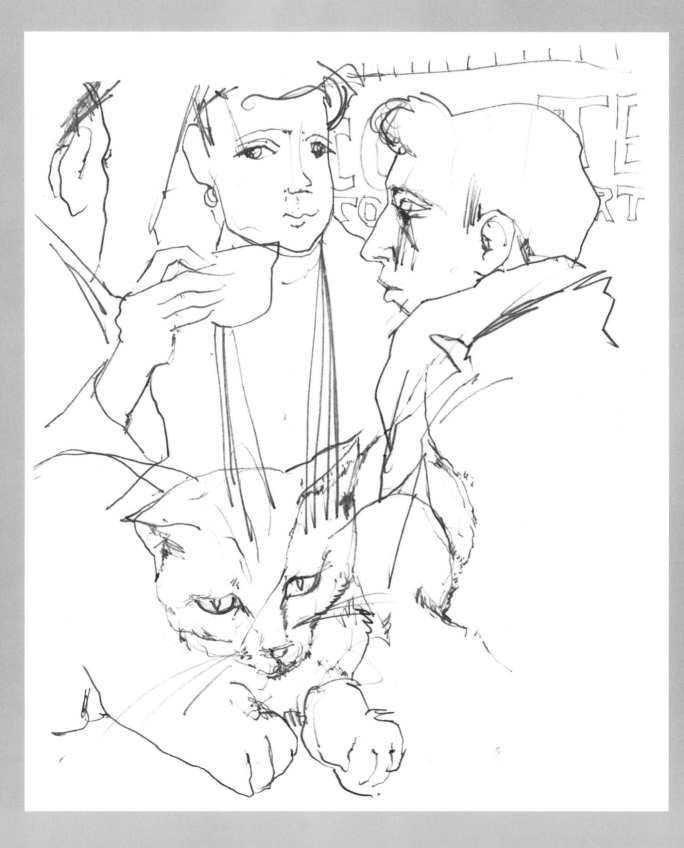

Figures

Drawing the human form, whether in portrait or in the whole body, undoubtedly presents the supreme challenge to an artist and, to many, the greatest reward. But, how to start what might seem a daunting task? 'As with all drawing,' suggests George Cayford, 'try to depict what you see in front of you as best as you are able.' It is the act of drawing that matters. Try drawing people on a large sketchpad, making many sketches of the same subject on the same sheet — it does not matter if they overlap. Put your drawings away for a couple of days and then, if possible, ask your model to assume the same pose and compare your drawings with the pose. This will put you in a properly critical frame of mind which will enable you to distinguish clearly the more successful parts from those less so.'

It is an excellent idea to join a local art class where life drawing is on the syllabus. 'Or ask a friend or relative to pose for you,' adds Jack Yates. 'People are less shy of revealing their bodies than when I was a student.'

On the opposite page are sketches overlaid with guidelines. All bodies articulate in order to distribute their weight, change their attitude or, in the case of the head, observe impressions — seeing, hearing, smelling, tasting. When you look at your model try to see these inner lines of articulation. Notice how hips slope when the weight is on one leg, how the shoulders compensate. With reclining figures, look for the spine line.

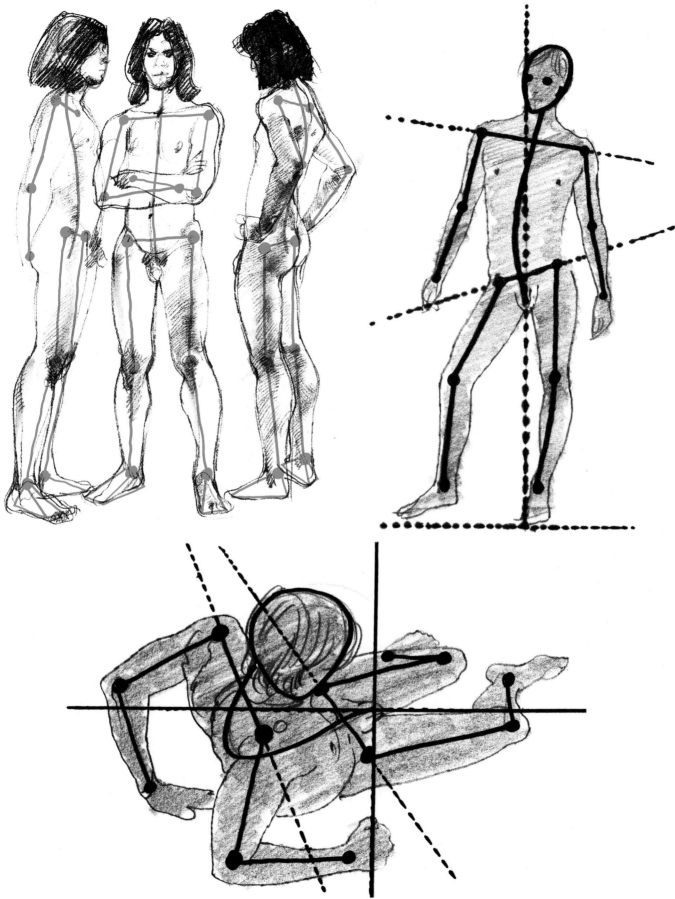

Figures

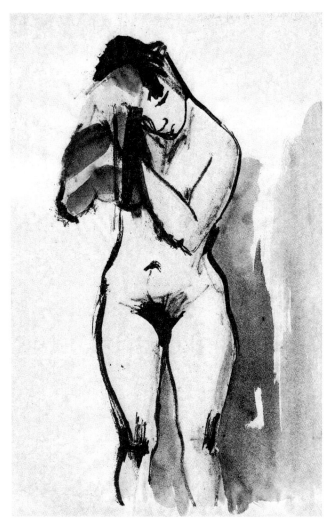

Above: *woman drying her hair, in Indian ink brush, with watercolour washes.* Above, right: *figure study in ball-point pen shaded to accentuate the forms.* Below, left: *reclining figure, in 2B pencil.* Below, right: *standing woman, in dip pen and black ink. Try to see the articulation lines.*

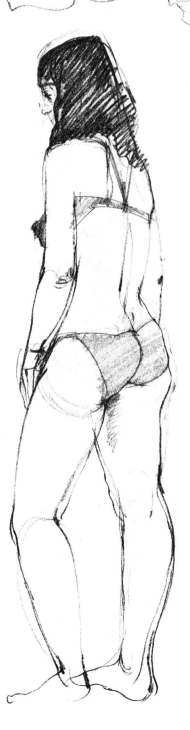

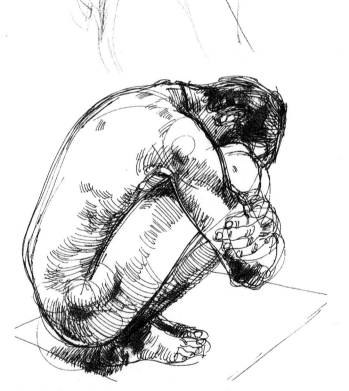

Always try to make your model feel relaxed. In the top drawing, in soft pencil, one feels the repose of the sitter. Left: *if your female model is shy of posing in the nude she may be prepared to do so in a swimming costume or bikini — her form will be sufficiently revealed for you to capture the overall pose. (6B pencil.)*

Above: *notice how all the forms overlap in this crouching form — somewhat of a challenge, but think of the articulation lines and the pose will become less complicated to understand. (Indian ink and dip pen, with touches of black pastel.) Drawings by George Cayford, except for page 100, top left and bottom right, by Jack Yates.*

Figures

Above are two sketches in conté which aim to capture poses and articulation. 'Use a medium that will give you quick results,' George Cayford says. 'Soft charcoal, conté or pastel can be quickly applied, the lines of the figure repeated, and tonal areas blocked in or smudged with the finger to give a general effect. When drawing people in clothes look for the parts which touch the angles of the form and imagine the body underneath. Once you have established this, drape the clothing over as you see how it falls or clings to the form.'

Left: Not only is the form detailed in but the skin colour is expressed in this study of a black model.
Opposite, above: 'Draw extremities whenever you can,' recommends Cayford. 'Try to envisage them as geometric forms: wedges, blocks, cylinders. Just as the body has articulation lines, look for them in detail in hands and feet.'
Opposite page, *below*. Footballers. When you have studied the figure in repose, try drawing moving figures. It does not matter if you leave a drawing unfinished, or if it overlaps another, it is *practice* that matters.

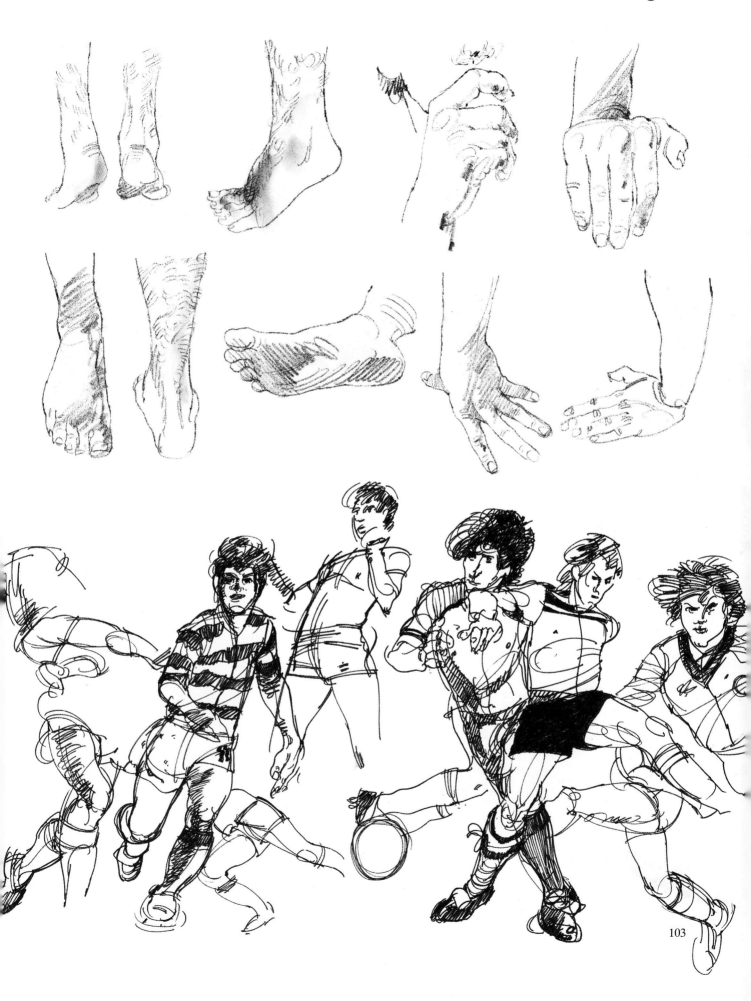

Portraits

Portraiture extends back in time well before the classical Greeks — the painted bust of the Egyptian Queen Nefertiti is idealised, yet its charm and beauty captures our imagination sufficiently to convince us that she probably looked very like it.

Portraiture serves a variety of functions, principally to identify but also to depict character. For no other part of our body reveals so much of our personality to the outside world as our face. Our faces undergo many metamorphoses from birth to extreme old age. What we eat and drink affects them, as do our dispositions. Moods, attitudes, happiness, sorrow are all projected in the face we present to others. And if that is not enough, we paint our faces, sprout moustaches and beards, grow our hair long, cut it off, put jewellery in ears and around our necks in order, consciously or unconsciously, to present to the world in the best possible light that part of us which projects our personality to others.

Seeing the skull beneath the skin may sound a morbid way to approach portraiture, but if we understand its basic shapes and its articulation on the neck and shoulders, we can more easily clothe it with flesh and hair, and ornament it with ears, eyes, nose and mouth. As demonstrated on pages 98–9, draw articulation lines through the head and shoulders and across the eyeline and mouth to see if your observations of your subject are accurate. Your first model is easily found. Indeed Jack Yates recommends self-portraiture for practising your drawing: 'If I can't find anyone else to draw I just look in the mirror.'

When you are confident that you understand the basic anatomy of head and shoulders, ask a relative or friend to sit for you.

Make him or her comfortable, and reduce the chore of sitting by playing the radio or recorded music. As in drawing from life, do not weary your sitters by posing them for too long. And always show your results, mistakes and successes; for the sitter is a participant in what is, after all, a shared activity.

Top, right: *child and mother (felt tip pen).* Below, left: *girl (dip pen and Chinese ink).* Below, right: *young man with beard (willow charcoal stick).*

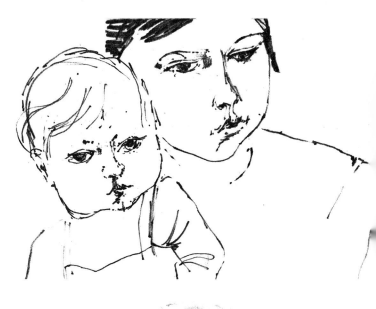

104

A page of portrait sketches by Jack Yates.
Top, left: *pencil studies of himself — notice how his expression changes in each quick study.* Above, top: *girl's head, in black ink and flexible dip pen.* Above: *black girl with turban and jewellery, in soft pencil. Yates has made a separate study of her eye.* Below: *girl reclining (in sepia ink and flexible dip pen).*

Portraits

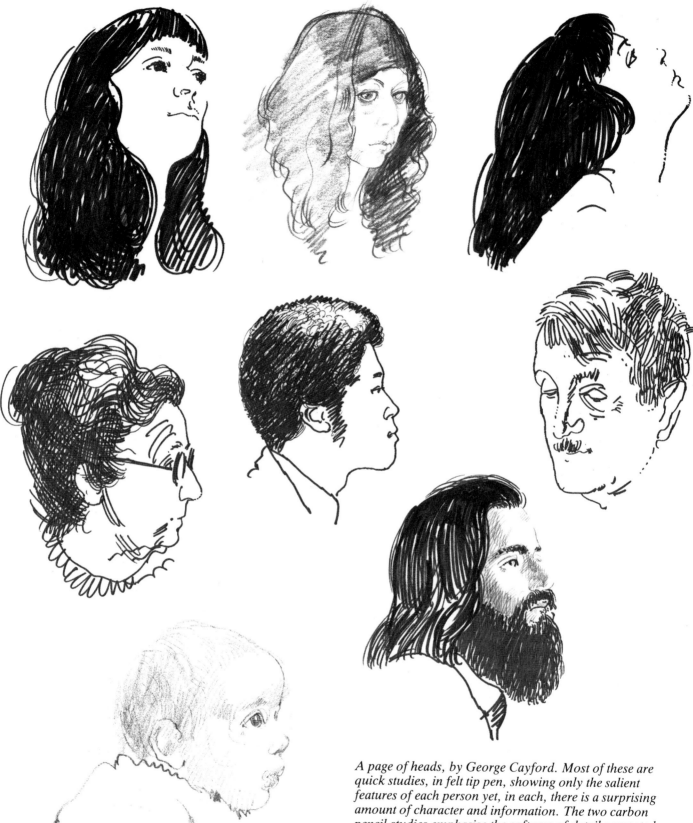

A page of heads, by George Cayford. Most of these are quick studies, in felt tip pen, showing only the salient features of each person yet, in each, there is a surprising amount of character and information. The two carbon pencil studies emphasise the softness of detail presented, especially in the baby's head. In the drawing (bottom, right) Cayford has used a combination of fine dip pen and black ink for the features, massing the hair and face in with broad strokes of thick felt tip pen.

Features

Eyes, noses, mouths, ears — these are some of the components of the portraits we draw. Their individual shapes and their relationship to each other on the head define identity and character — so practise drawing them separately and in combination. You will find that, with the probable exception of babies, no person's two eyes are replicas; the muscles a person uses in facial expression will, over the years, have pulled or developed each into a subtly different shape. So too with the mouth, one corner might droop or be upturned, or be affected by teeth (and dentistry). Think of features as simple geometric forms; parts of cylinders, or spheres. If you imagine them as being carved out of solid blocks, then your drawing instrument or medium can 'cut' through the block to the shape beneath. (See the drawings of ears on this page.) Notice too, how the angle of the head affects the shapes and relationships of features: such observation follows on naturally from looking at and taking note of foreshortening, as dealt with in the section on drawing the figure. (Drawings on this page by George Cayford.)

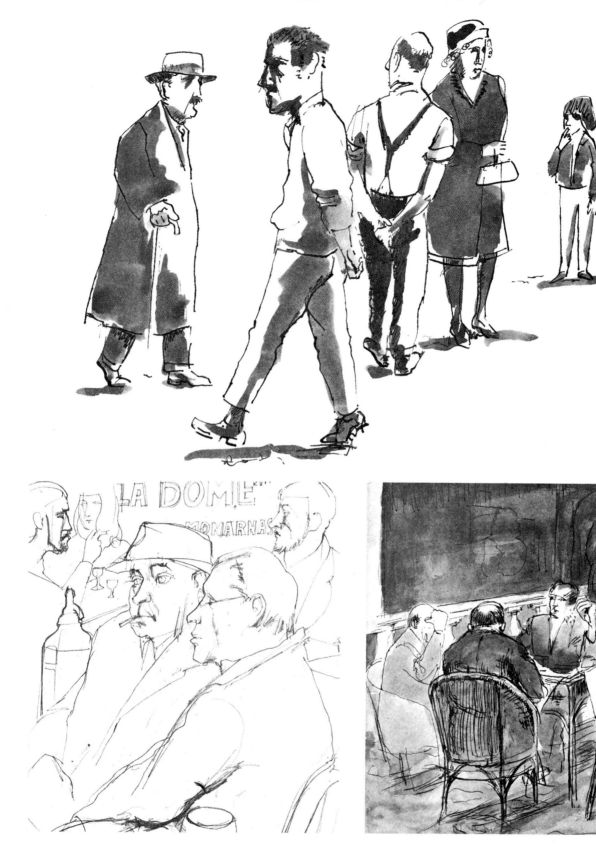

Figures in groups

'Try to draw people going about their daily business,' Jack Yates says, 'for nothing reveals people's characters so much as when they are working, eating or socialising.' In drawing two or more people the spatial relationship between them is important — if their bodies and faces are close together or overlap, it suggests intimacy; distance between them suggests that they are not necessarily related to each other at that particular

Top: *dip pen and washes of Chinese ink*. Below, left: *pencil*. Below, right: *dip pen and watercolour washes*.

moment. On this page the three drawings by Jack Yates all suggest pre-occupation, intimacy, business or curiosity. Also try, if possible, to include some of the setting: café or building site. Look for the positive and negative spaces of figures and surrounds. Capture your people's posture — exaggerate it even. One person's back within a group can be as informative as the faces of others.

Top, left: *sleeping hound (Indian ink and brush on rough surfaced watercolour paper)*. Below, left: *cat (fine felt tip pen and wax crayon background to give textural contrast)*. Above: *terrier (graphite drawing)*.

Animals

Animals, like humans, make fascinating and challenging subjects for drawing; but they lack one human virtue — they cannot keep still to order! So start to practise drawing animals when they are in repose, or asleep, like the brush drawing in Chinese ink of the sleeping hound. Animals' anatomy is often hidden by their hide or fur but, as with drawing clothed humans, look for the articulation of the skeleton; see the main shapes as cylinders, cones, blocks or spheres. Make several studies on one page. From several such sketches you will find one which pleases you more than the rest.

If you do not own a pet, use photographs or magazine pictures — but try to draw from live animals. Remember, as with all drawing, look at your subject more than you do at your sketch — with practice your mind will interpret what you see and translate the information to your hand.

On this page and on page 110 are drawings in various mediums by Clifford Bayly, Jack Yates and George Cayford: dogs, cats, sheep, birds, horses. Each drawing has something different to say about the animals they depict — repose, response to stimuli, textural quality, movement. Before you start to draw, study your pet or animal for several minutes. If possible, win your animal's acceptance by stroking or patting it (or, with farm animals, sit down and let them get used to your presence). While you are doing this make up your mind which quality best sums up what you wish to depict — shape, furriness, etc. Fix on that quality and reach with eye and mind towards it. Thus, your lines and marks will express the characteristic you wish to achieve. Do not worry if your subject continually moves: concentrate on the head, for example, or the shapes of the movements, or the anatomy of its rump.

Take your sketchbook with you when you go to the zoo or attend horse or dog shows. Wildlife films are often shown on television — get out your drawing pad and pencil and sketch what you see — it will build up your confidence to work quickly.

Animals

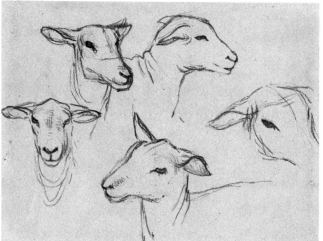

Top, right: *studies of a sheep's head drawn in 2B pencil on grey sugar paper by Clifford Bayly.* Above: *gulls in flight (fine dip pen and ink with touches of wash) by Jack Yates.* Below: *horse studies in fine dip pen and sepia ink, also by Jack Yates. Not only does each sketch indicate restlessness on the part of the subject: the whole page is alive with movement.*

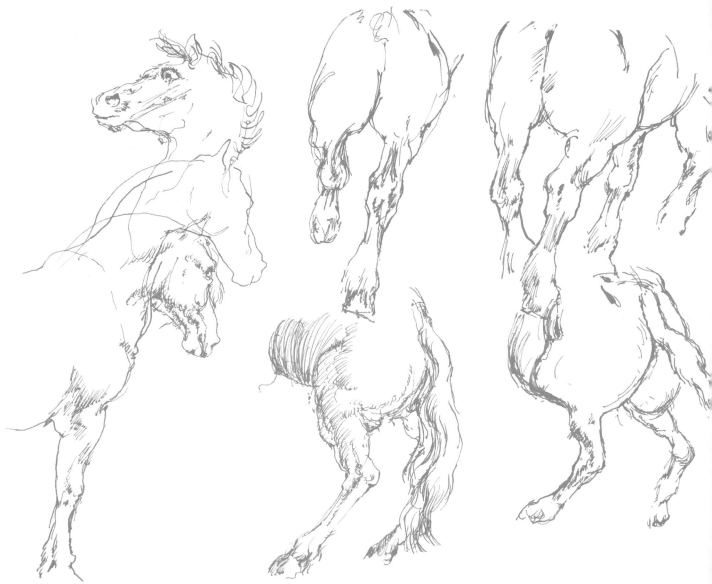

The artists' sketchbook

'*Disegnia antonio disegnia antonio
disegnia e non perder tempo*'
('*Draw Antonio, draw Antonio,
draw and do not waste time*').

MICHELANGELO (1475-1564)

written to his assistant Antonio Mini on
a sheet containing two sketches of his for
the Virgin and Child in brown ink
(c 1522), now in the British Museum.

Editor's note

Artists' sketchbooks are goldmines of information, expression and, above all, the most intimate insight into the way they work; for they embody their own personal shorthand of the world about them. Whether for information or feeling, like correspondence to a friend or loved one, their visual expressions record their preoccupations, interests (and obsessions) of what they most pertinently desire to portray. Five of the artists whose work is shown in the previous pages have generously lent their sketchbooks or pages ripped out of layout pads, and so reveal themselves to you, the onlooker. From their hundreds of drawings I have had the delightful (but unenviably difficult) task of selecting those which show the artists for what they are: masters of their craft engaged in their most personal work, or transmitting to students information they have acquired over years of experience.

Look at their drawings, then, not so much as finished works but as a shorthand expression of how they see life and inanimate objects. As editor of this book I asked each artist to give a brief introduction to his or her approach to visual notetaking. I have deliberately left out technical information about the drawings, for by now you will recognise the many methods used. My choice was not dictated by sheer quality but by what you, the reader, could learn from, having observed thus far. All of us, the artists and myself wish you enthusiasm as you work and guidance from their example; and may your sketchbooks be filled — like theirs — with an abundance of what you feel you wish to record, visually and expressively, of the world about you.

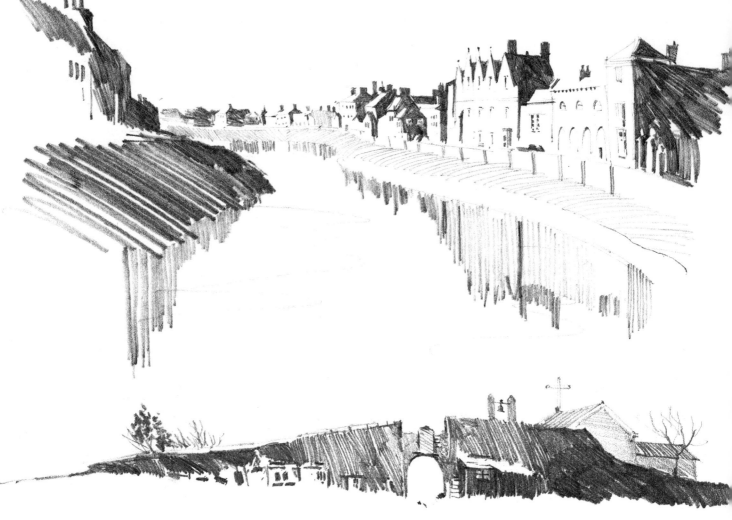

Richard Bolton

'I use small sketchbooks — usually they are of good watercolour paper, and sometimes I add colour notes. At other times I use a large layout pad of cheap paper, making rapid pencil sketches. Buildings, details of buildings, and industrial artefacts have always fascinated me; it is the way that things are put together which captures my interest — bridges or locks, for example, or even rotting machinery. No doubt this stems from my early training and practice as a technical illustrator.'

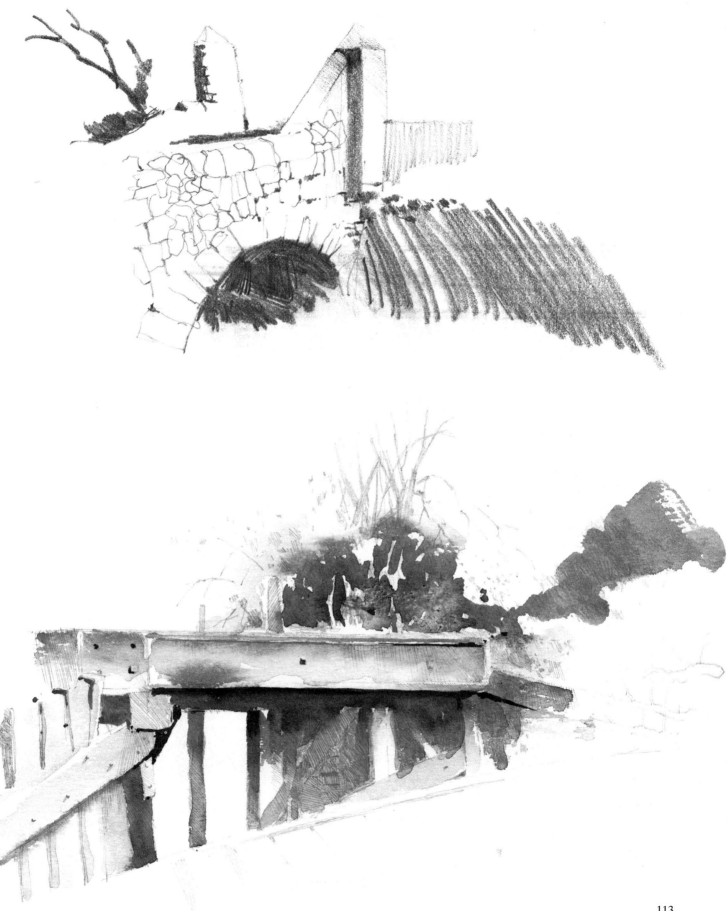

Richard Bolton

Margaret Merritt

'As nearly a dozen years of my professional life were taken up accompanying botanical expeditions, mainly to remote regions of the Middle East as official artist, my sketching equipment became refined down to essentials. When I sketch now, it is with paintings in mind: when I teach, I use different mediums and paper to show my students the breadth and variety of materials available to them (see page 115). My own approach to drawing and painting is probably best described by saying that I am fascinated by the interface between the attitude where one is artistically subservient to nature, and where one's own personal interpretation of natural subjects predominates.'

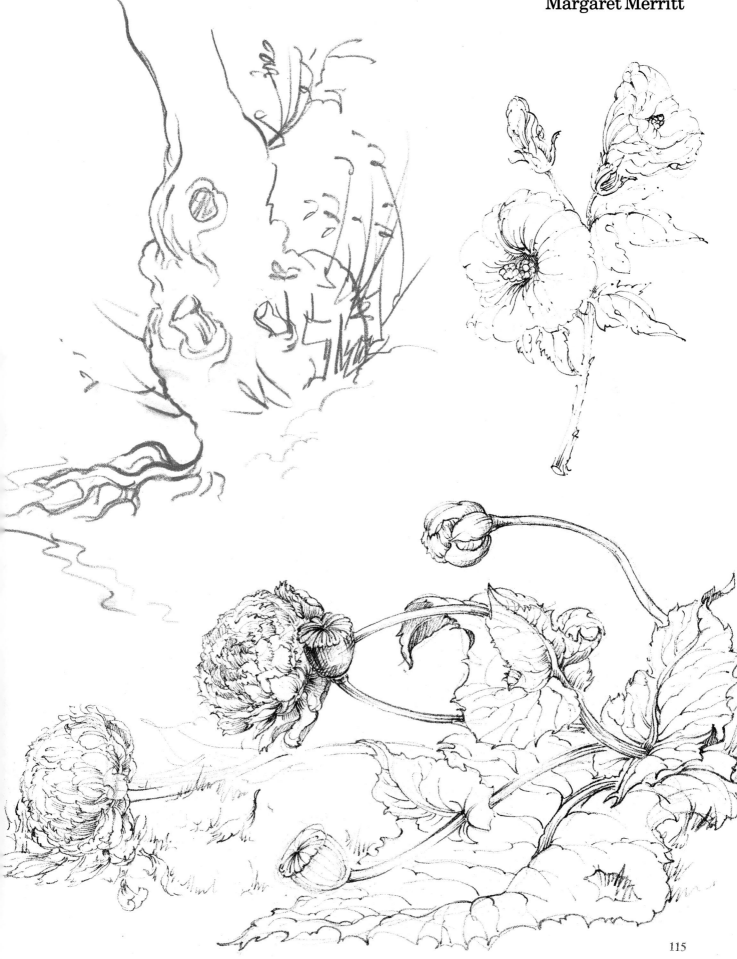

Margaret Merritt

Margaret Merritt

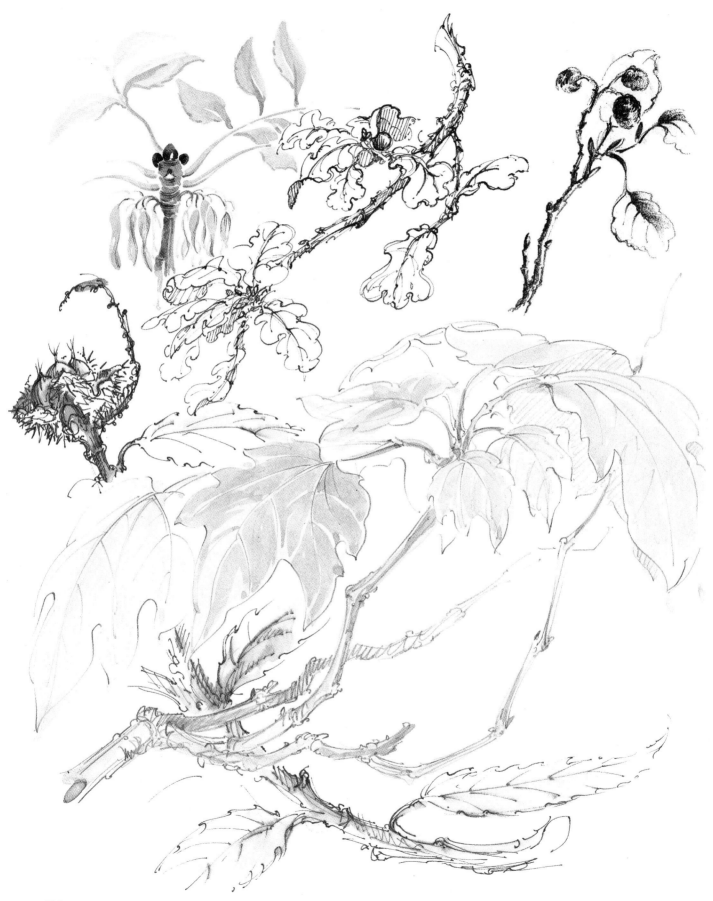

Jack Yates

'For me my sketchbooks are a visual diary. I use them for making rapid notes of the things and people that interest me at the time. Sometimes I "square" my sketches up for paintings, but mostly they serve as an evocative record of events seen and felt. I carried my first sketchbook when I was in the army in Normandy — it was lost with all my other possessions shortly after but, years later, I saw the First World War drawings of the German artist Otto Dix and realised we had recorded the same horrors, but on different sides in different wars. People interest me most, especially women: when I draw women clothed or nude I try to capture their sensuous quality in the lines I draw. I am also interested in exploring traditional and new forms of graphic techniques, from Chinese bamboo pens to the reproductive techniques of photomontage and *cliché verre*. This interest shows in the multi-medium sketchpage which I did for my students (page 119).'

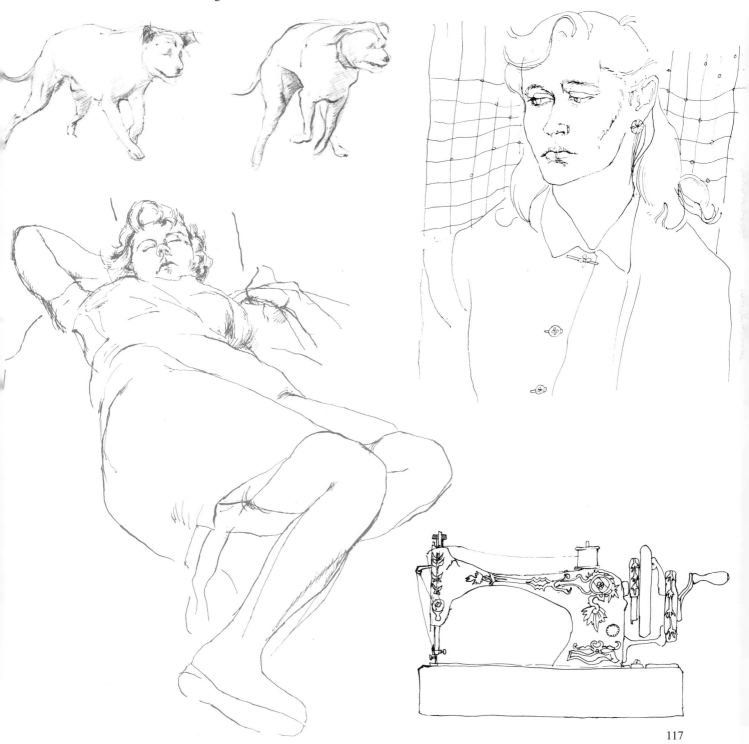

Jack Yates

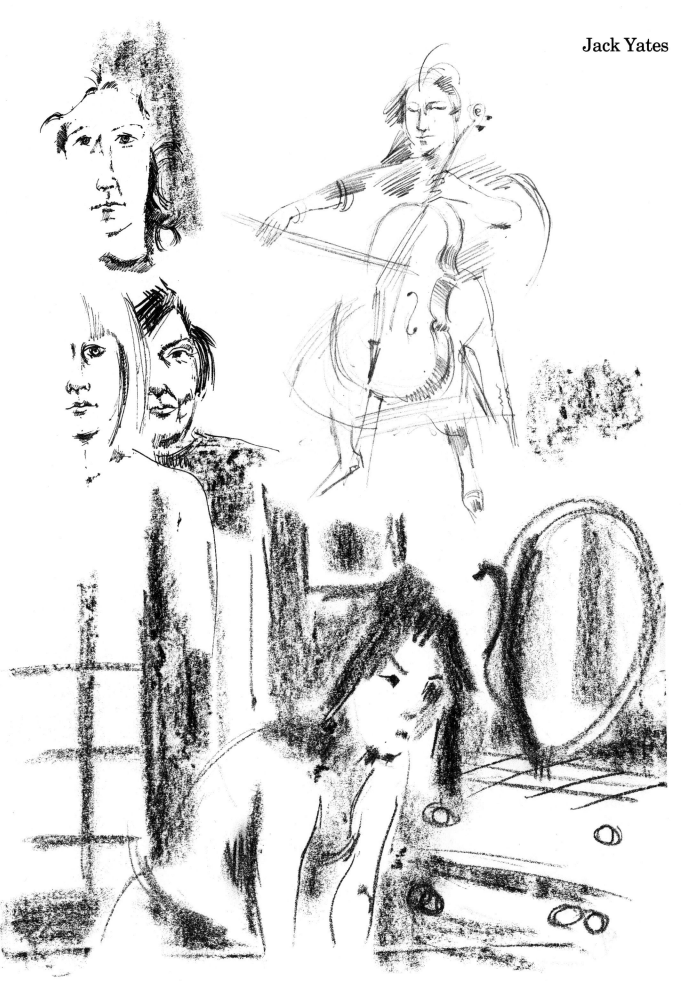

Clifford Bayly

'I use my sketchbook in all sorts of ways: to record people, animals, places and objects. I put down colour notes, textures, make rubbings even with soft wax on textural surfaces that interest me. When drawing people I like to be as unobtrusive as possible so I can catch them unawares; scratching themselves, or in the way they hold things, their reactions to odd happenings — sudden showers, a loud noise in the street.

'The landscapes that interest me most bear the impact of man's influence: cart tracks, ploughed fields, buildings in cities, signs and letterings on shop fronts, all catch my eye, as does the activity in street markets. I look for the unusual amongst the familiar or vice versa. Needless to say, I am hardly ever without my sketchbook, and always carry a variety of pencil stubs on me (as well as pens, ink and felt markers in my car).'

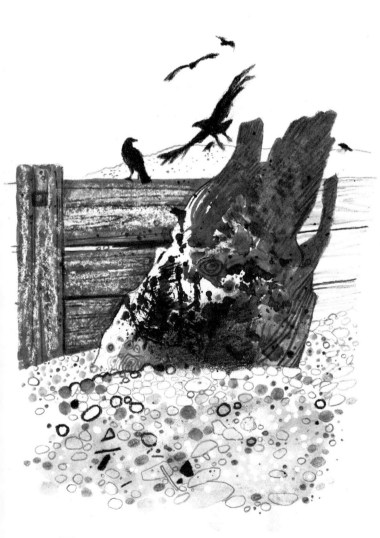

Clifford Bayly

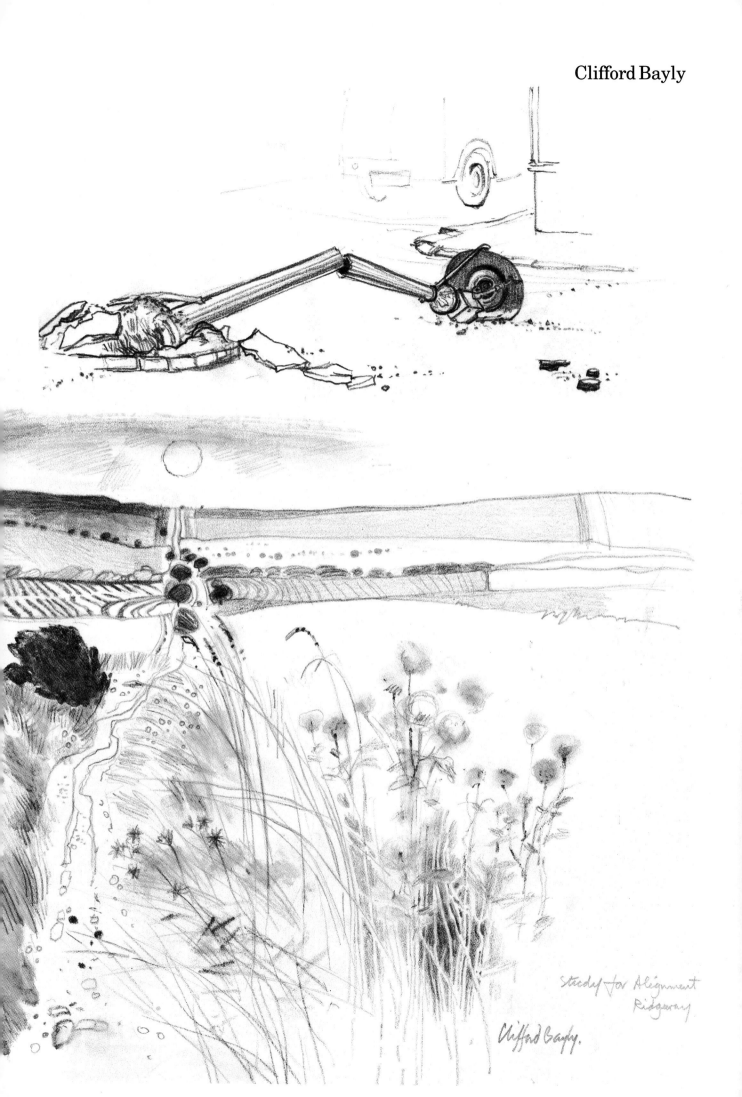

Study for Alignment
Ridgeway

Clifford Bayly.

George Cayford

'I rarely use sketchbooks nowadays, my main interest being in drawing people posed in the studio. For my sketchwork I use a large A2 layout pad, making large drawings of my models, often several studies on the one page. When I am out of my studio however, I practise what I call "mental sketching": I look at people in pubs, cafés, buses and trains and I draw them in my mind. I imagine what medium I would use and go through the process of drawing in my mind's eye, so you could say I am constantly practising! I look at people to find out what makes each individual different from the rest of us: not only physical features and clothes, but how they sit, stand, lean, lie, move. I am very much attracted by the theatre and ballet where people are body- and clothes-conscious — also by the fads and fashions of the dissenting young. I use colour: pastel, crayon, marker, inks, to draw with; my finished pictures are *not* coloured drawings but drawings in colour.'

George Cayford

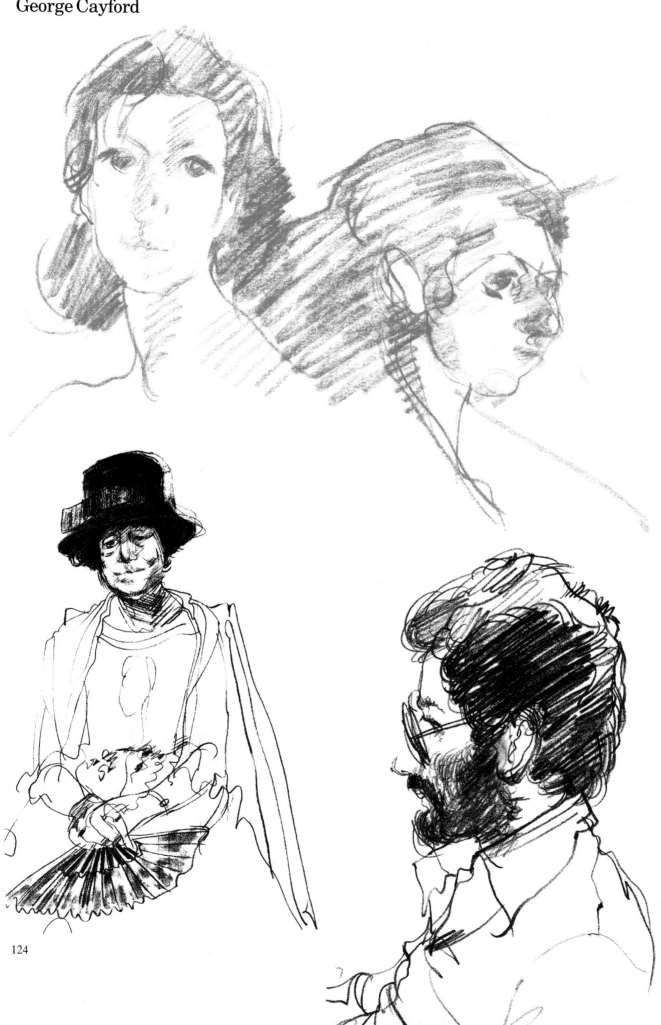

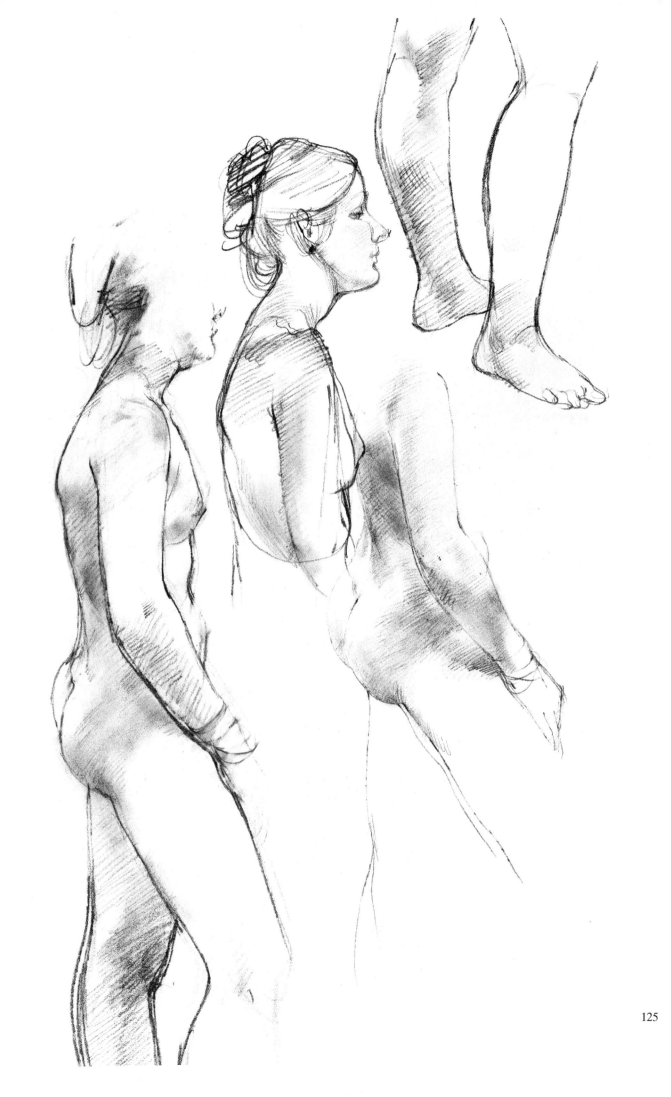

Afterword

While I was working on this book, one point struck me more than any other. There is a certain 'rightness' about the drawings: each artist has met the informational or expressive requirement or statement he or she wished to make, be it the most informal of study sketches, or a completely finished drawing. Another fact which these reveal is that there is no one 'correct' style for drawing any given object, person or scene. Style is the outward manifestation of individuality, yet the one quality the artists have in common is their ability to control their drawing hand by means of eye, brain (and practice!) to produce what they intend. All of them told me at one time or another, and in different ways, the same message: 'we can show you how to draw, but only constant practice will give you the results you aim for'.

Drawing for Pleasure has now, through several hundred instances, shown you 'how'. Remember the apt (and urgent) message of Michelangelo to his assistant quoted on page 111. Apply it to yourself, as have all the artist contributors to this book. Copy their work, not to imitate their style but to understand the mechanics of drawing. Try out the effects of different mediums, making marks, lines, tones with a purpose, go about your world using the 'seeing eye'. Just as the child on page 7 is getting simple satisfaction and delight from her drawing, sooner or later you too will gain the satisfaction of producing work which demonstrates effectively the skill of your craft and the style of your art.

Index of artists' work

Under the name of each of the artists represented is given the page number and position of his or her work illustrated.

Key

top left	tl
top middle	tm
top right	tr
top	t
middle left	ml
middle right	mr
middle	m
bottom left	bl
bottom middle	bm
bottom right	br
bottom	b

Where whole page numbers are given only, all the work on those pages are by that artist.

BATTERSHILL, Norman:

28 b; 30 t; 33; 38; 39; 40; 41; 44 t; 46; 47; 48 t; 62 bl, br; 63 ml, br; 70 br; 82 tr, tm; 83; 86.

BAYLY, Clifford:

8; 9; 10; 12 bl; 13; 14; 15; 16; 18 mr; 19 tl, ml, br; 20 tl, tr, ml, mr; 22; 23; 24 bl, tr; 26; 27; 28 tl, tr; 29; 30 mr, br; 31; 50–1 b; 55 b; 57; 63 t; 64; 67 tr; 72 tl; 73; 74 mr; 75 b; 76; 77 tl; 78 mr; 79 tl, ml, mr; 80 tr; 109 tl; 110 tr; 120–22.

BLOCKLEY, John:

58–9.

BOLTON, Richard:

title page; 18 b; 74 tr, b; 75 t; 77 m, b; 78 tl, ml, b; 79 b; 80 tl, bl; 87 b; 112–13.

CAYFORD, George:

half-title; 11 tl; 12 br; 18 ml; 20 br; 21; 24 tl; 25; 32; 34; 35; 36; 37; 43; 44 b; 45; 48 br; 56; 72 tr; 81; 84–5; 88–94; 95 tr, br; 98–9; 100 tr, bl; 101–3; 104 br; 106–7; 109 ml, tr; 123–25.

FROST, Dennis:

42.

GILMAN, Peter:

63 mr.

MERRITT, Margaret:

11 tl, m; 17; 49; 50 tr, mr; 51 t; 52–4; 55 t; 60–1; 65–6; 67 tl, bl, mr; 68–9; 70 tl, tr; 71; 72 mr; 82 bl; 114–16; 126.

MILLER, Jane:

photograph, 7.

STEPHENSON, Laura:

7 t.

WORTH, Leslie:

62 m.

YATES, Jack:

19 tr; 87 tr; 95 bl; 96–7; 100 tl, br; 104 bl, mr; 105; 108; 110 tl, b; 117–19.